TABLE OF CONTENTS

McGraw-Hill

Orchestrations for Orff Instruments

GRADE 4

SHARE the Music

McGRAW-HILL

SERIES AUTHORS

Judy Bond
Coordinating Author

René Boyer-Alexander

Margaret Campbelle-Holman

Marilyn Copeland Davidson
Coordinating Author

Robert de Frece

Mary Goetze
Coordinating Author

Doug Goodkin

Betsy M. Henderson

Michael Jothen

Carol King

Vincent P. Lawrence
Coordinating Author

Nancy L. T. Miller

Ivy Rawlins

Susan Snyder
Coordinating Author

Contributing Writer
Janet McMillion

McGraw-Hill
School Division

New York Farmington

ACKNOWLEDGMENTS

Grateful acknowledgment is given to the following authors, composers, and publishers. Every effort has been made to trace the ownership of all copyrighted material and to secure the necessary permissions to reprint these selections. In the case of some selections for which acknowledgment is not given, extensive research has failed to locate the copyright holders.

Geordie Music Publishing Company for *Golden Ring Around the Susan Girl* by Jean Ritchie. © 1963, 1971 Jean Ritchie.

Shirley W. McRae for *I Don't Care If the Rain Comes Down*, American folk song, arranged by Shirley McRae. ©1993 Shirley W. McRae.

MMB Music, Inc. for *Fed My Horse* from THE CAT CAME BACK by Mary Goetze. © 1984 MMB Music, Inc., Saint Louis. Used by Permission. All Rights Reserved. For *Mongolian Night Song* from SONGS OF CHINA by Gloria Kiester and Martha Chrisman Riley. © 1988 MMB Music, Inc., Saint Louis. Used by Permission. All Rights Reserved.

Contributing Writer
Anna Marie Spallina

McGraw-Hill School Division

A Division of The McGraw-Hill Companies

INTRODUCTION

The Orff approach to music education actively involves students in speech, movement, singing, instrument playing, and drama. Developed by German composer Carl Orff (1895–1982), the approach is based on the instinctive learning behavior of children. Improvisation and movement permeate the learning process, and use of the specially designed Orff instruments enables children to create and perform ensemble music at every level.

The materials used include both folk and composed music, along with chants, rhymes, and poetry. As students experience this music they develop a musical vocabulary and skills that may then be used to create original works.

Orff orchestrations have been created for selected songs in SHARE THE MUSIC. Along with each orchestration are teaching suggestions. The teaching suggestions include:

Instrumentation—A chart is given showing letters for specific bars used on mallet instruments for each song. Unused bars are shown as □. All parts except timpani are commonly written in the treble clef. Bass xylophone and bass metallophone sound an octave below the written pitch. Soprano xylophone, soprano metallophone, and alto glockenspiel sound an octave above the written pitch. The soprano glockenspiel sounds two octaves above the written pitch. The alto xylophone and alto metallophone sound at the written pitch.

Teaching the Orchestration—A suggested basic teaching sequence is given for each orchestration. In orchestrations the bass part is usually the most important. Students must be secure with this part before other parts are added. Except for the bass pattern, most parts may be considered optional. The teacher may choose to use only some of the suggested orchestration depending on circumstances—such as ability of students, the time available, or the accessibility of specific instruments. Many of the arrangements can be musically satisfying with only the bass part and one other part added for tone color and/or rhythmic interest.

Form—Suggestions for the final form may include introductions, interludes, codas, chants, and opportunities for improvisation.

Noteworthy—This is a list of important musical elements that can be reinforced with the orchestration.

The Orff approach can infuse music classes with a spirit of cooperation and joy, enabling students to develop concentration and perception skills, increased aesthetic awareness and physical coordination, and a high level of motivation.

0•1 Oh, Won't You Sit Down?

INSTRUMENTATION

SX/AX □□□□ **G A B** □□□□□□□ tambourine, suspended cymbal, recorder, timp., bass
AM □ **D E** □ **G A B** □ **D E** □ **G A** bars (opt.)
BX □□□□ **G** □□□ **D** □□ **G** □

TEACHING THE ORCHESTRATION

1. Teach the bass xylophone part in the refrain.

Have the students:
- Mirror you as they pat the rhythm of the BX part, using the following pattern:

 L R L R L R R R L R L R L R CROSS rest

- Take turns playing the BX part on any available barred instruments.
- Sing the refrain as one student plays the BX part.

2. Teach the soprano xylophone/alto xylophone/recorder parts in the refrain.

Have the students:
- Sing the song, clapping on the words *Lord, I can't sit down*.
- Take turns playing the SX/AX part on any available barred instrument.
- Sing the refrain as some students play the BX and SX/AX parts.
- Finger the notes on the recorder as you sing the pitch names.
- Play the refrain on the recorder as some students play the BX and SX/AX parts and some students sing.

3. Add the alto metallophone and timpani (bass bars, optional) part in the refrain.

Have the students:
- Snap the rhythm of the AM part as they sing the refrain.
- Play any two notes of the G pentatonic scale in the AM rhythm part on any available barred instrument.
- Play the G bass bars in the same rhythm.
- Combine the AM and timpani parts with the BX, SX/AX, and recorder parts as they sing the refrain.

4. Teach the suspended cymbal and tambourine parts in the verse.

Have the students:
- Sing the verse, clapping on the question *Who's that yonder dressed in red?* and patting on the answer *Must be the children that Moses led.*
- Transfer the rhythm of the question to the suspended cymbal (played with a stick or mallet handle), the rhythm of the answer to the tambourine.

FORM

Refrain: Voice, SX/AX, AM, BX, S. Rec., Timp.
Verse: Voice, S. Cym., Tamb.

NOTEWORTHY

Rhythm: dotted quarter note, syncopation
Melody: G pentatonic
Harmony: I-V

0·1 Oh, Won't You Sit Down?

African American Spiritual
Arranged by Carol King

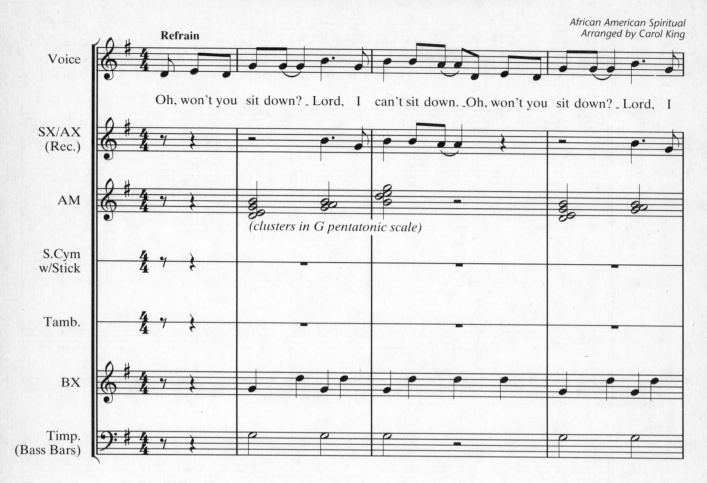

(clusters in G pentatonic scale)

Oh, won't you sit down? Lord, I can't sit down. Oh, won't you sit down? Lord, I

McGraw-Hill

Oh, Won't You Sit Down? (continued)

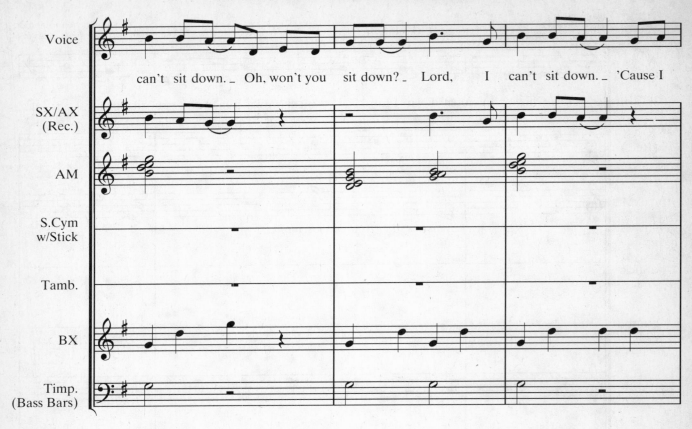

can't sit down. _ Oh, won't you sit down? _ Lord, I can't sit down. _ 'Cause I

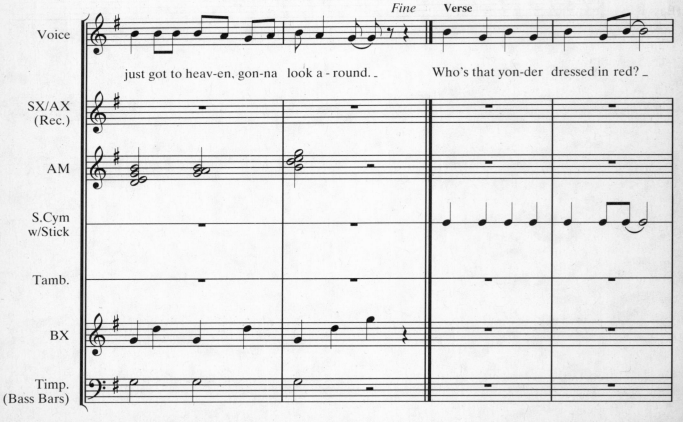

just got to heav-en, gon-na look a - round. _ Who's that yon-der dressed in red? _

McGraw-Hill

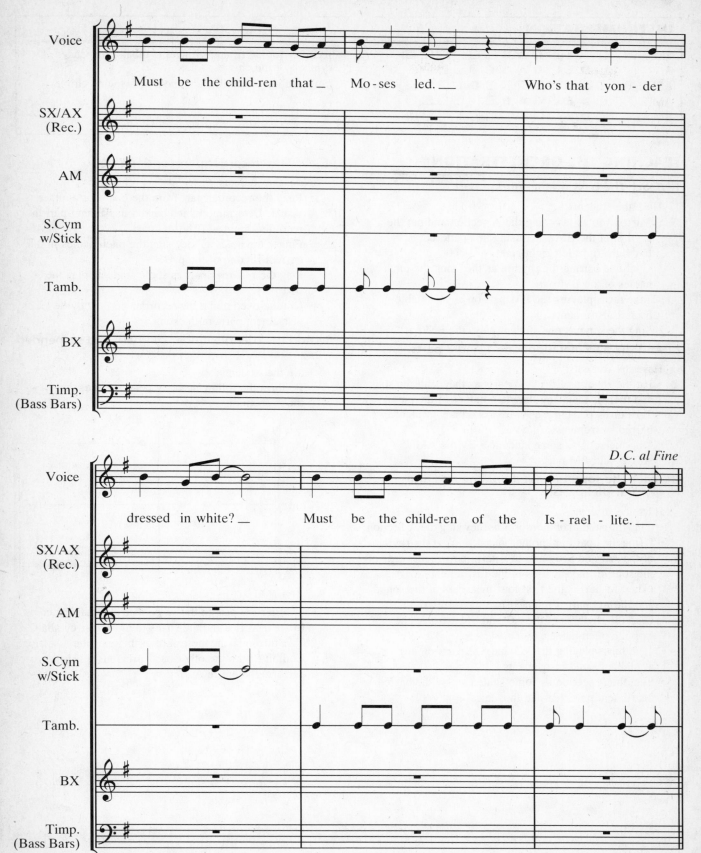

0·2 Mongolian Night Song

INSTRUMENTATION

SM	□	□	**E**	□	**G**	**A**	**B**	□	□	□	□	□	□
AG	□	**D**	**E**	□	**G**	**A**	**B**	**C**	□	□	□	□	□
AM 1	□	□	□	□	□	□	□	□	**D**	**E**	□	□	□
AM 2	□	**D**	**E**	□	**G**	**A**	**B**	□	□	□	□	□	□
BM	□	**D**	**E**	□	□	□	□	□	□	**E**	□	□	□

recorder (opt.), triangle, finger cymbals, suspended cymbals, wind chimes
(Substitution possibility: chime tree for wind chimes)

TEACHING THE ORCHESTRATION

1. Teach the bass metallophone part.

Have the students:
- Mirror you as they sing the A section and pat the rhythm of the BM part, using this pattern: left-right-right-left-right-right.
- Continue patting the rhythm as they sing the pitch names of the BM part.
- Take turns playing the BM part on any available barred instruments.
- Sing the song as one student plays the BM part.

2. Add the alto metallophone 1 and 2 parts.

Have the students:
- Pat the rhythm of the AM parts as they sing the song and then as they sing the pitch names of the parts.
- Take turns playing the AM parts on any available barred instruments.
- Sing the song as some students play the AM 1, AM 2, and BM parts.

3. Teach the soprano metallophone and alto glockenspiel parts.

Have the students:
- Clap the rhythm of the words as they sing the A section.
- Using the board or another visual, look at the rhythms of the AG and SM parts to determine which words of the song fit the rhythms of the instrumental parts. (The SM part is the first four measures of the song, and the AG part is the next two measures.)
- Clap the rhythms of the AG and SM parts as they sing the pitch names.
- Take turns playing the AG and SM parts on any available barred instruments.
- Sing the A section as some students play the barred instrument parts learned thus far.

4. Add the recorder part (optional).

Have the students:
- Read the recorder part from the board or another visual. Determine which barred instrument part the recorder doubles. (The AG part.)
- Finger the notes as they sing the pitch names in the correct rhythm of the part.
- Play the recorder part as some students play the BM part.
- Gradually combine the recorder parts with the other instrument parts in the song.

5. Add the triangle, finger cymbals, and suspended cymbal parts.

Have the students:
- Perform the following body percussion as they sing the A section:

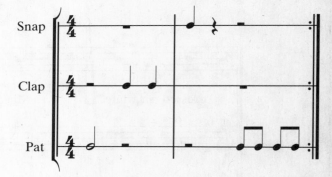

- Transfer the pats to the suspended cymbal, the claps to the triangle, and the snaps to the finger cymbals. Take turns playing these parts as they sing the A section.
- Combine with the other parts previously learned to perform the entire A section.

McGraw-Hill

6. **Teach the bass metallophone, alto metallophone 1 and 2, and wind chime parts in the instrumental interlude.**

Have the students:

· Pat the rhythm of the BM part in this section.

· Play the BM part on any available barred instruments.

· Mirror you as you show a tremolo with your hands on one knee. (You may choose to have the students play the D tremolo in another way: holding two mallets in one hand, handles touching together in the palm making a "V" shape, one mallet over the end of the metallophone bar and one mallet underneath the bar, moving the hand quickly up and down.)

· Take turns playing the D tremolos of the AM part as one student plays the BM part.

· Have one student play the wind chime at the beginning of each measure.

· Combine all the parts learned thus far.

7. **Add the alto glockenspiel part in the instrumental interlude.**

Have students:

· Clap the rhythm of the AG part as they sing the pitch names.

· Take turns playing the AG part on any available barred instruments.

· Combine with the other parts to perform the entire B section.

FORM

A section:	Voice, AG, SM, AM, BM, Tri., F. Cym., S. Cym., Rec. (opt.)
B section:	AG, AM, BM, W. Ch., Rec. (opt.)
A¹ section:	Voice, AG, SM, AM, BM, Tri., F. Cym., S. Cym., Rec. (opt.)

NOTEWORTHY

Rhythm:	$\frac{4}{4}$, quarter notes, eighth notes, half notes
Melody:	E minor
Harmony:	I

0·2 Mongolian Night Song

Traditional Inner Mongolian Song, Collected and Translated by Gloria Kiester Arranged by Carol King

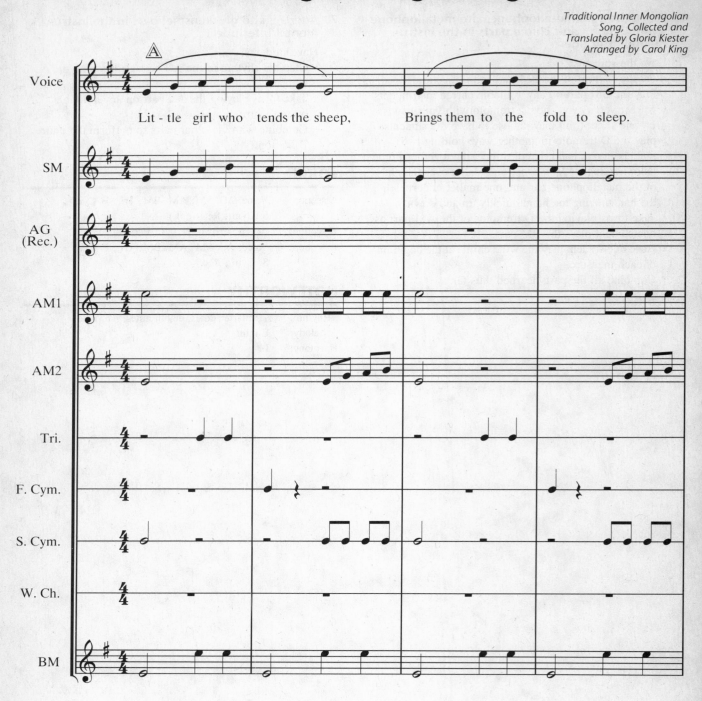

Lit - tle girl who tends the sheep, Brings them to the fold to sleep.

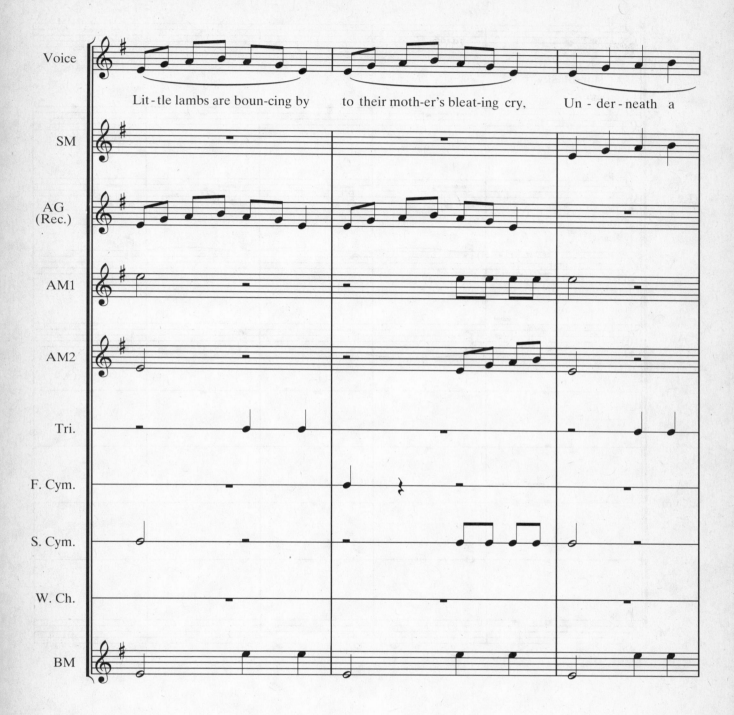

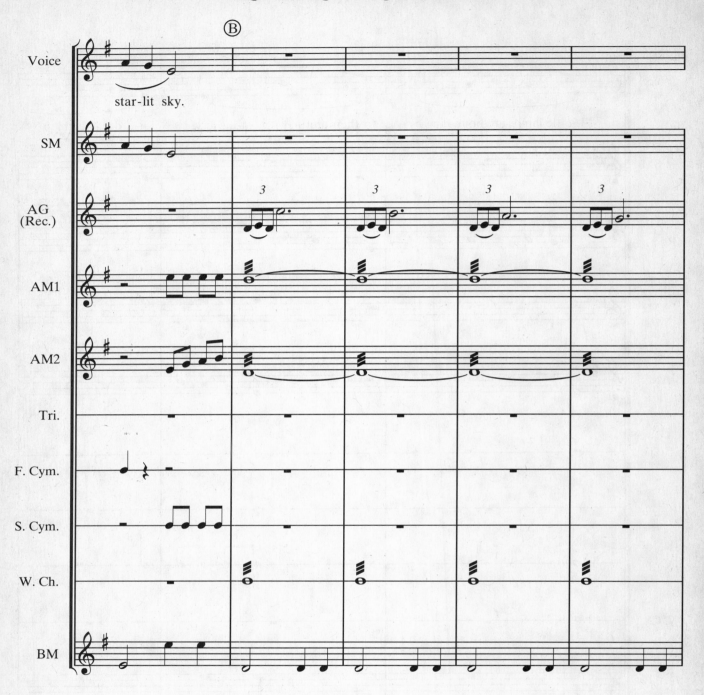

star-lit sky.

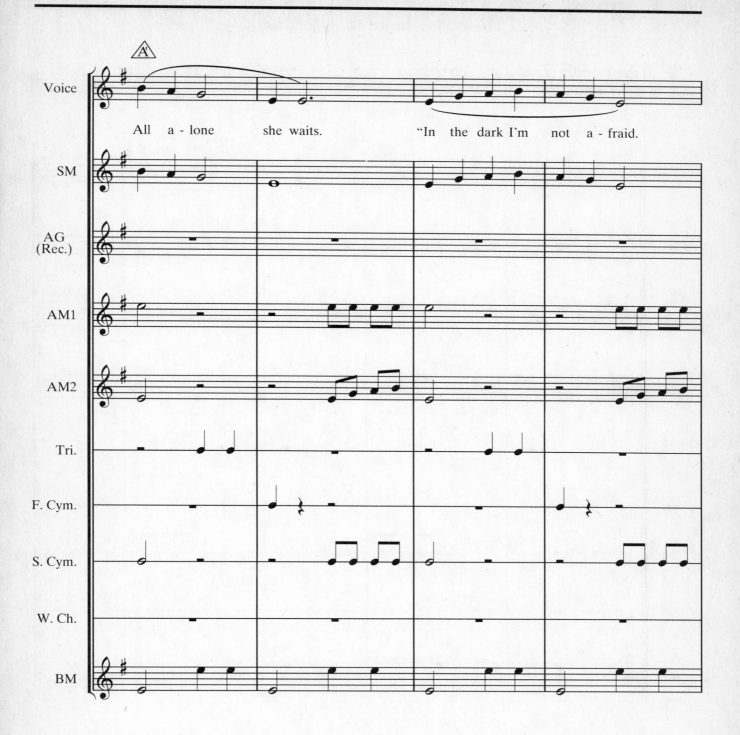

All a - lone she waits. "In the dark I'm not a - fraid.

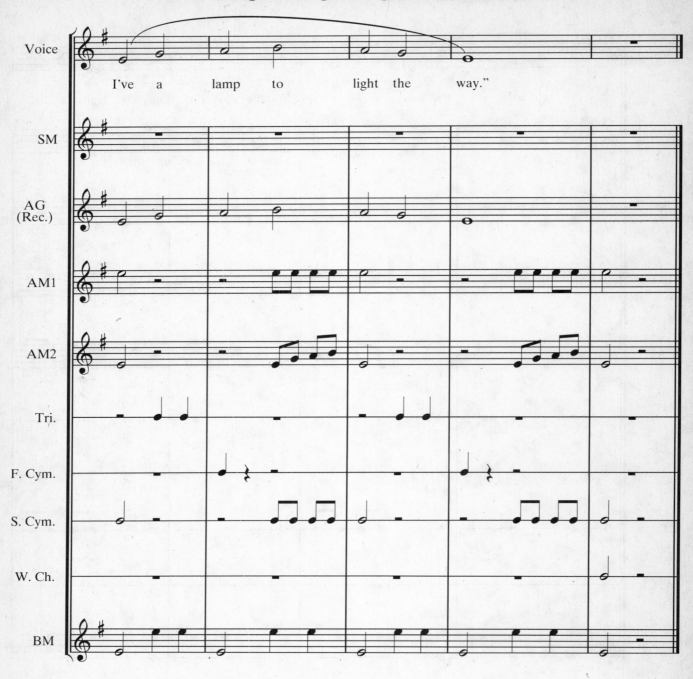

I've a lamp to light the way."

0•3 Fed My Horse

INSTRUMENTATION

AX ☐ ☐ **E F G A B♭ C** ☐ ☐ ☐ ☐ ☐

BX ☐ ☐ ☐ **F** ☐ ☐ ☐ **C D** ☐ ☐ ☐ ☐

sticks, claves (opt.), tambourine
(Substitution possibility: claves for sticks)

TEACHING THE ORCHESTRATION

1. **Teach the bass xylophone part in the verse.**

 Have the students:
 - Pat the rhythm of the BX part as they sing the verse.
 - Play the BX part in the air, mirroring the teacher.
 - Echo-sing the pitch names as they pat the rhythm of the BX part, singing the top notes first and then the bottom notes.
 - Take turns playing the BX part on any available barred instruments.
 - Sing the verse as one student plays the BX part.

2. **Add the sticks part in the verse.**

 Have the students:
 - Clap the rhythm of the melody as they sing the verse.
 - Take turns playing the rhythm on sticks (claves).
 - Sing the verse as some students play the BX and the sticks.

3. **Add the alto xylophone part in the verse.**

 Have the students:
 - Echo-sing the pitch names as they clap the rhythm of the AX part.
 - Take turns playing the AX part on any available barred instruments.
 - Sing the verse as some students play all the parts learned thus far.

4. **Teach the bass xylophone part in the refrain.**

 Have the students:
 - Mirror you as they pat the rhythm of the BX part, patting the half notes in the left hand and the quarter notes in the right hand. Or assign two students to play top and bottom notes. Or have the AX play the right-hand notes and the BX play the left-hand notes.
 - Take turns playing the BX part on any available barred instruments.
 - Sing the refrain as one student plays the BX part.

5. **Add the tambourine part in the refrain.**

 Have the students:
 - Sing the refrain, clapping on the words *Coy malindo*.
 - Take turns playing this rhythm on the tambourine, tapping lightly near the rim, as they sing the refrain. Then add the BX part.
 - Perform the entire orchestration.

FORM

Verse:	Voice, AX, BX, Sticks
Refrain:	Voice, BX, Tamb.

NOTEWORTHY

Rhythm:	quarter notes, eighth notes, sixteenth notes
Melody:	F major
Harmony:	bordun

0·3 Fed My Horse

Southern Appalachian Folk Song
Arranged by Mary Goetze
Adapted by Carol King

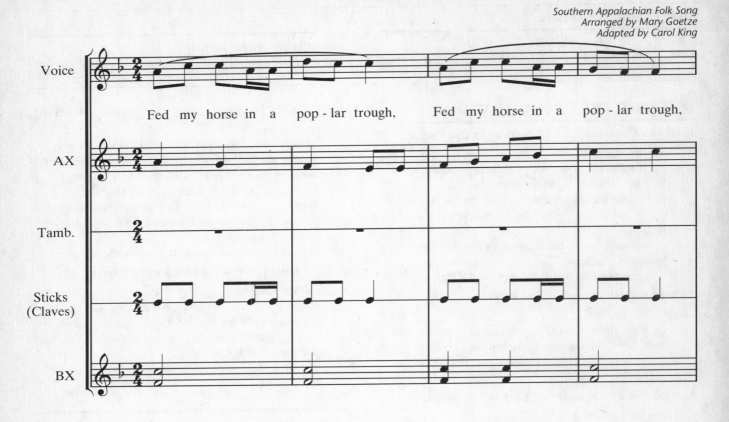

Fed my horse in a pop - lar trough, Fed my horse in a pop - lar trough,

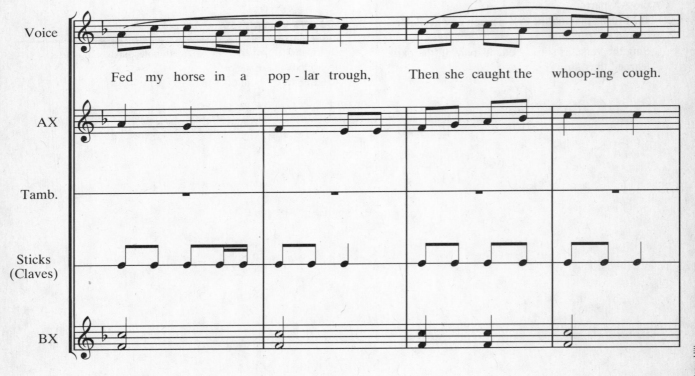

Fed my horse in a pop - lar trough, Then she caught the whoop-ing cough.

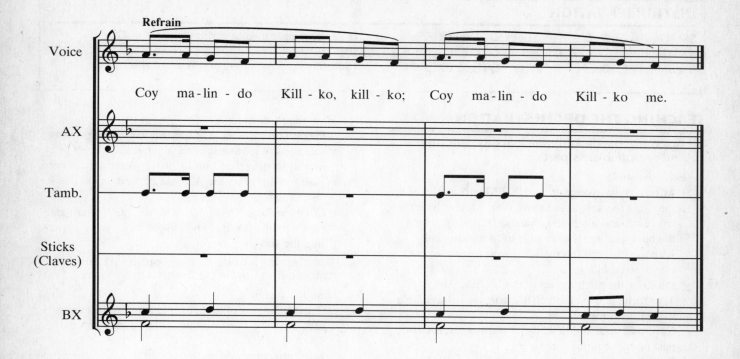

Coy ma - lin - do Kill - ko, kill - ko; Coy ma - lin - do Kill - ko me.

0·4 Trail to Mexico

INSTRUMENTATION

SX/AG	□	D	E	□	□	□	□	□	D	E	□	□	□
AX/AM	□	□	E	□	G	□	B	□	D	□	D	□	□
BX/BM	□	D	□	□	G	□	□	□	D	□	□	□	□

triangle, temple blocks, timpani—tuned to G, bass bars (opt.)

(Substitution possibility: bass bars for timpani)

TEACHING THE ORCHESTRATION

1. **Teach the bass xylophone/bass metallophone and temple blocks parts.**

 Have the students:
 - Mirror you as you play the BX/BM part and, while they sing the song, pat the rhythm, starting with the left hand, and alternating hands. Determine where the bass part needs to change to fit harmonically with the melody. (on the word *west*, changing back on the word *mile*)
 - Discover the pitch names of the BX/BM part.
 - Take turns playing the BX/BM part on any available barred instruments.
 - Have one student double the rhythm of the BX/BM part on the temple blocks.
 - Sing the song as one student plays the BX/BM and another plays the temple blocks part.

2. **Add the alto glockenspiel/soprano xylophone part.**

 Have the students:
 - Mirror you as they sing the song and pat the rhythm of the AG/SX part, shifting their hands slightly to the right for the second note and back for the third note.
 - Continue patting the rhythm as they sing the pitch names of the AG/SX part.
 - Take turns playing the AG/SX part on any available barred instruments.
 - Sing the song as some students play the BX/BM, AG/SX and temple block parts.

3. **Teach the alto xylophone/alto metallophone part.**

 Note: You may have each student play all three notes of the chords by using three mallets, or you may distribute the notes among three players.

 Have the students:
 - Pat the rhythm of the AX/AM part as they sing the song.
 - Practice the harmonic change pattern as shown in Step 2, shifting the hands to the left on the second note.
 - Take turns playing the AX/AM part on any available instrument.
 - Combine the AX/AM part with the AG/SX part and then with the BX/BM and temple block parts as they sing the song.

4. **Add the timpani (bass bars, optional) and triangle parts on verse 3 only.**

 Have the students:
 - Clap the rhythm of the timpani part. Determine which parts have the same rhythm. (The AG/SX and the AX/AM parts)
 - Take turns playing the timpani part.
 - Have one student double the rhythm of the melody on the triangle, striking lightly on the side.
 - Perform the entire orchestration, adding the timpani part, as they sing the song.

FORM

Verse 1:	Voice, AG/SX, AX/AM, BX/BM, TB
Verse 2:	Same as verse 1
Verse 3:	Voice, AG/SX, AX/AM, BX/BM, TB, Bass Bars (opt.), Timp., Tri.

NOTEWORTHY

Rhythm:	quarter notes, eighth notes, sixteenth notes
Melody:	G major
Harmony:	I-V

0·4 Trail to Mexico

American Cowboy Song
Music Adapted by Carol King
Arranged by Carol King

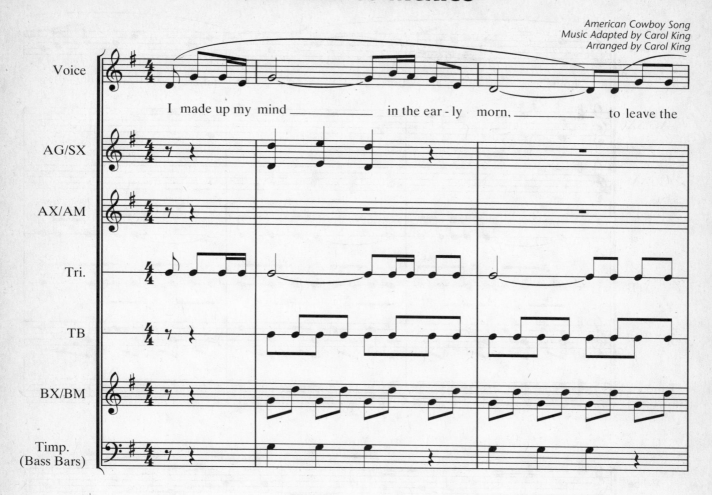

I made up my mind _____ in the ear - ly morn, _____ to leave the

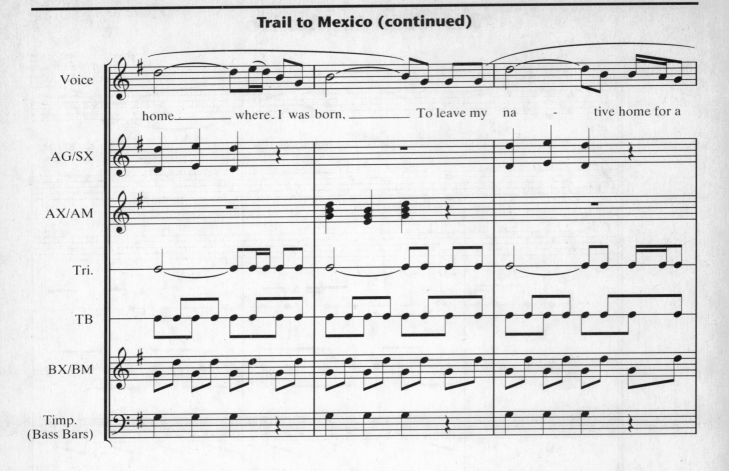

home_____ where I was born,_____ To leave my na - tive home for a

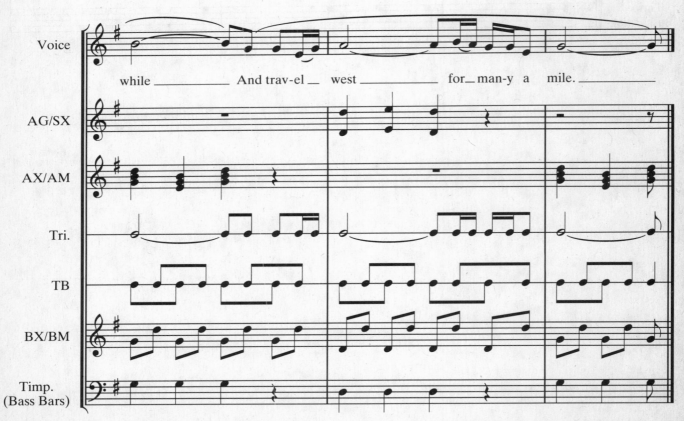

while_____ And trav-el___ west_____ for_ man-y a mile._____

0·5 Down the Road

INSTRUMENTATION

AX	☐ **D E** ☐ **G A B** ☐ ☐ ☐ ☐ ☐ ☐
AM	☐ **D E** ☐ **G A B** ☐ **D E** ☐ **G** ☐
BX	☐ ☐ ☐ ☐ **G** ☐ ☐ ☐ **D** ☐ ☐ ☐ ☐

tambourine, bongo drums, suspended cymbal, sand blocks, temple blocks

TEACHING THE ORCHESTRATION

1. **Teach the bass xylophone part in the A section.**

 Have the students:
 - Pat the rhythm of the BX part using alternating hands, beginning with the left hand, and sing the song.
 - Take turns playing the BX part on any available barred instruments.
 - Sing the A section as one student plays the BX part.

2. **Add the alto xylophone and sand blocks parts in the A section.**

 Have the students:
 - Sing the A section, clapping on the words *down the road* and making a rubbing motion with their palms to the rhythm of the words *come along and walk together*.
 - Continue to clap the AX part as they sing the pitch names.
 - Take turns playing the AX part on any available barred instruments.
 - Take turns playing the sand blocks to the rhythm of the words *come along and walk together*.
 - Sing the A section as some students play the BX, AX, and sand blocks parts.

3. **Teach the alto metallophone part in the A section.**

 Have the students:
 - Sing the A section as they snap on the fourth beat of every measure with the words *down the road* (or after the word *road*). Tell the students to make every snap in the air in a different place.
 - Play any two notes of the following on any available barred instruments: D E G A B D E G. This is the AM part. Remind the students to pick two new notes each time.
 - Combine the AM part with the other parts previously learned.

4. **Teach the tambourine, suspended cymbal, temple blocks, and bongo parts in the B section.**

 Have the students:
 - Read the B section from the board or another visual: ("Swing" the rhythms.)

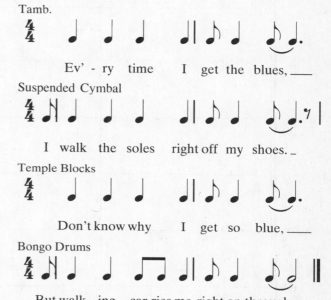

Assign each line to the corresponding instrument.

FORM

A:	Voice, *tutti* instruments
B:	Voice, *tutti* instruments
A:	Voice, *tutti* instruments
B:	Voice, *tutti* instruments
A:	Voice, *tutti* instruments

NOTEWORTHY

Rhythm:	quarter notes, eighth notes, syncopation
Melody:	G major

0·5 Down the Road

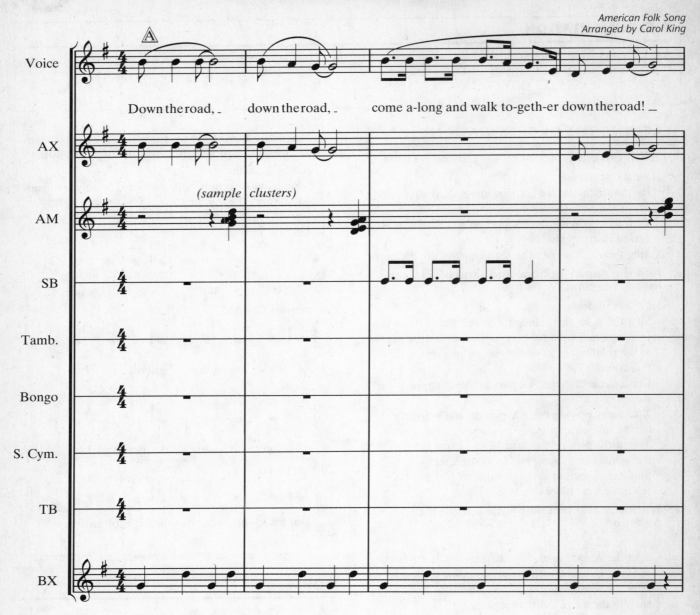

American Folk Song
Arranged by Carol King

Down the road, down the road, come a-long and walk to-geth-er down the road!

(sample clusters)

Voice

AX

AM

SB

Tamb.

Bongo

S. Cym.

TB

BX

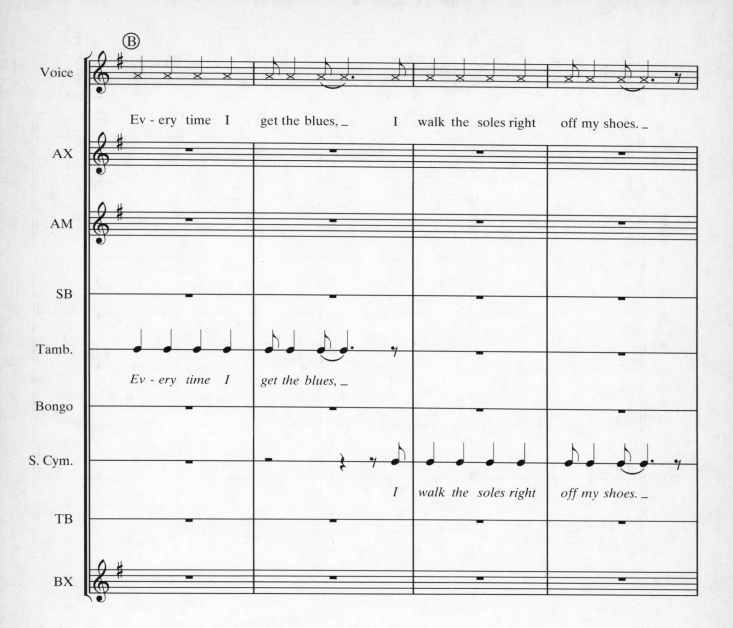

Down the Road (continued)

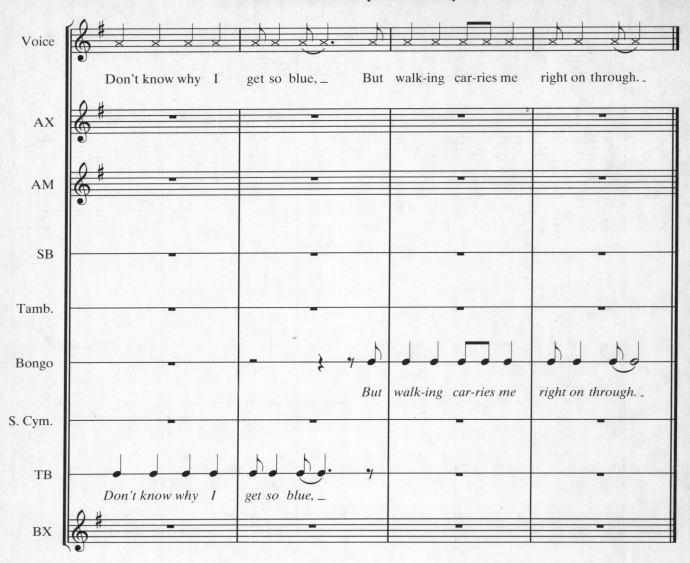

Voice: Don't know why I get so blue, _ But walk-ing car-ries me right on through. _

Bongo: But walk-ing car-ries me right on through. _

TB: Don't know why I get so blue, _

0·6 I Don't Care If the Rain Comes Down

INSTRUMENTATION

SG/AG	**C**	**D**	**E**	**F**	**G**	☐	☐	☐	☐	☐	☐	**G**
SX/AX	**C**	**D**	**E**	☐	**G**	☐	☐	☐	☐	☐	☐	
AM	**C**	☐	☐	☐	☐	☐	☐	**C**	☐	☐	☐	☐
BX	**C**	☐	☐	☐	**G**	☐	☐	**C**	☐	☐	**C**	☐

woodblock, güiro, tambourine

TEACHING THE ORCHESTRATION

1. Teach the bass xylophone part in the A section.

Have the students:
- Pat the rhythm of the BX part with both hands, shifting the left hand to the right on the second beat of the third measure, as they sing the A section.
- Take turns playing the BX part on any available barred instruments.
- Sing the A section as one student plays the BX part.

2. Add the soprano xylophone/alto xylophone part in the A section.

Have the students:
- Pat the rhythm of the SX/AX part with alternating hands, beginning with the right hand, as they sing the A section.
- Take turns playing the SX/AX part on any available barred instruments.
- Sing the A section as some students play the BX and SX/AX parts.

3. Add the soprano glockenspiel/alto glockenspiel part in the A section.

Have the students:
- Pat the rhythm of the SG/AG part.
- Notice that in the first measure the notes are struck together and in the second measure the same notes are struck separately.
- Sing the A section as some students play the SX/AX and SG/AG parts.

4. Add the güiro part in the A section.

Have the students:
- Clap the rhythm of the güiro part as they sing the A section. You may wish to use the following speech pattern to help learn the rhythm:

O - kay! Car-ry me a - way to - day.

- Take turns playing the güiro part with the other instruments previously learned.

5. Teach the bass xylophone part in the B section.

Have the students:
- Pat the rhythm of the BX part with alternating hands, beginning with the left hand, as they sing the B section.
- Take turns playing the BX part on any available barred instruments.
- Sing the B section as some students play the BX part.

6. Add the tambourine part in the B section.

Have the students:
- Clap the rhythm of the tambourine part as they sing the B section.
- Take turns playing the tambourine as one student plays the BX part.

7. Teach the soprano glockenspiel/alto glockenspiel part in the B section.

Have the students:
- Clap the rhythm of the SG/AG part as they sing the B section and then as they sing the pitch names.
- Take turns playing the SG/AG part on any available barred instruments.
- Sing the B section as some students play the BX, SG/AG, and tambourine parts.

8. Teach the alto metallophone part in the B section.

Have the students:
- Clap the ryhthm of the AM part as they sing the B section of the song.
- Play the AM part on any barred instrument.
- Sing the B section as some students play the AM part.

9. Add the woodblock part in the B section.

Have the students:
- Pat the rhythm of the WB part with alternating hands as they sing the B section.
- Take turns playing the WB part with the BX part and then combine all the instruments learned to perform the entire orchestration.

FORM

A: Voice, SG/AG, Güiro, SX/AX, BX
B: Voice, SG/AG, SX/AX, AM, BX, Tamb., WB

NOTEWORTHY

Rhythm:	eighth notes, sixteenth notes
Melody:	C major
Harmony:	I

0·6 I Don't Care If the Rain Comes Down

American Folk Song
Arranged by Shirley McRae

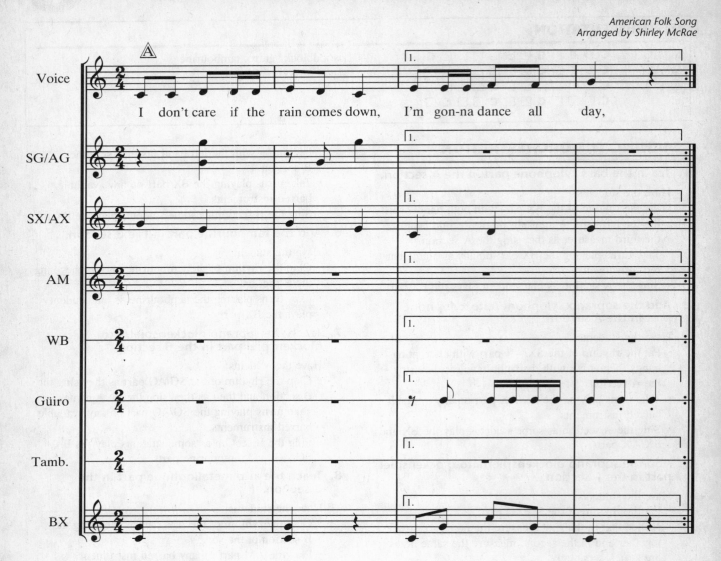

I don't care if the rain comes down, I'm gon-na dance all day,

Rainstick (ad lib. throughout.
If not available, have students
choose another instrument for rain sounds.)

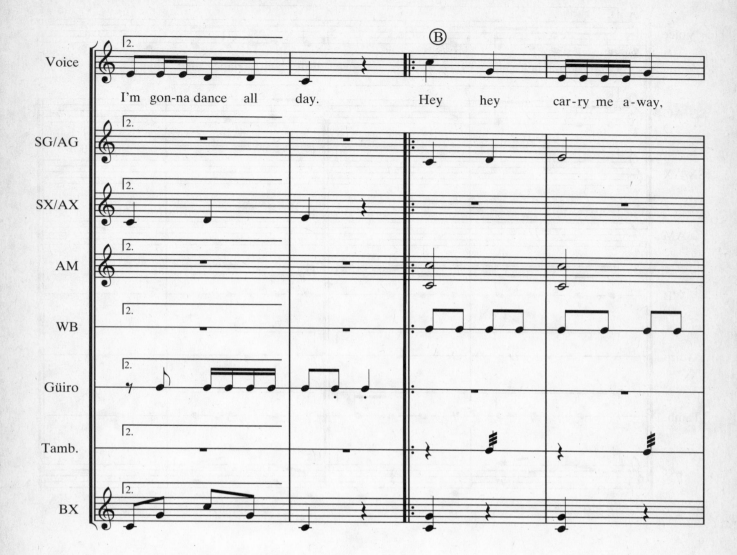

I'm gon-na dance all day. Hey hey car-ry me a-way,

I Don't Care If the Rain Comes Down (continued)

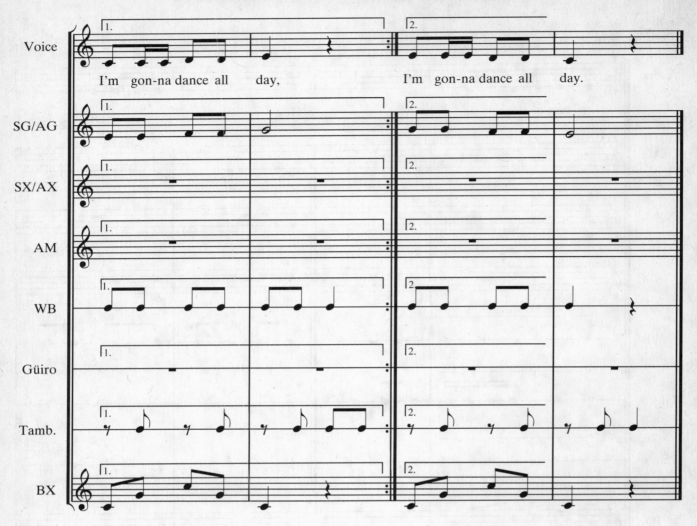

I'm gon-na dance all day,

I'm gon-na dance all day.

0·7 One More River

INSTRUMENTATION

AG/SX	☐ ☐ ☐ ☐ ☐ **A** ☐ **C D** ☐ ☐ ☐ ☐
AX	**C** ☐ ☐ ☐ ☐ ☐ ☐ ☐ ☐ ☐ ☐ ☐
BX/BM	**C** ☐ ☐ **F** ☐ ☐ ☐ **C** ☐ ☐ ☐ ☐

recorder (opt.), triangle, temple blocks, güiro, timpani—tuned to C and F
(Substitution possibility: bass bars for timpani)

TEACHING THE ORCHESTRATION

1. Teach the bass xylophone/bass metallophone part.

Have the students:
- Pat the rhythm of the BX/BM part with both hands, shifting the left hand to the left on the third measure and back to position on the fourth measure as they sing the song. You may wish to use words to help learn the BX/BM part:

No - ah built an ark.

- Take turns playing the BX/BM part on any available barred instruments.
- Sing the song as one student plays the BX/BM part.

2. Add the alto xylophone part.

Have the students:
- Pat the rhythm of the AX part with alternating hands, beginning with the right hand, as they sing the song.
- Take turns playing the AX part on any available barred instruments.
- Sing the song as some students play the BX and AX parts.

3. Add the triangle part.

Have the students:
- Clap the rhythm of the triangle part as they sing the song. Determine to which part it is similar (it has the same rhythm as the BX part).
- Take turns playing the triangle part with the other instruments previously learned.

4. Teach the güiro and temple block parts.

Have the students:
- Perform the body percussion pattern as shown below, read from the board or another visual:

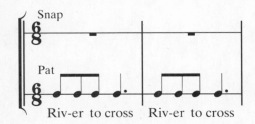

Snap

Pat

Riv-er to cross Riv-er to cross

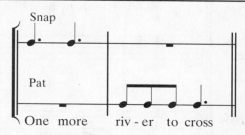

Snap

Pat

One more riv - er to cross

- Transfer the pats to the temple blocks and the claps to the güiro. Take turns playing these instruments with the BX and AX parts as they sing the refrain.

5. Add the timpani (bass bars, optional) part.

Have the students:
- Clap the rhythm of the timpani part as they sing the refrain, then as they sing the pitch names.
- Take turns playing the timpani as one student plays the BX part.

6. Teach the alto glockenspiel/soprano xylophone part.

Have the students:
- Sing the refrain, clapping on the words *one more river*.
- Take turns playing the AG/SX part.
- Sing the refrain as some students play all the parts learned thus far.

7. Add the recorder part (optional).

Have the students:
- Read the recorder part from the board or another visual. Determine which barred instrument part the recorder doubles. (The AG/SX part.)
- Finger the notes as they sing the pitch names in the correct rhythm of the part.
- Play the recorder part as some students play the BX/BM part.
- Gradually combine the recorder parts with the other instrument parts in the song.

FORM

| Verse: | Voice, AX, BX/BM, Tri. |
| Refrain: | Voice, AG/SX, AX, BX/BM, Tri., Güiro, TB, Timp., Bass Bars (opt.), Rec. (opt.) |

NOTEWORTHY

Rhythm:	6_8, eighth notes, sixteenth notes
Melody:	F major
Harmony:	I-V

0·7 One More River

Nineteenth Century College Song
Arranged by Carol King

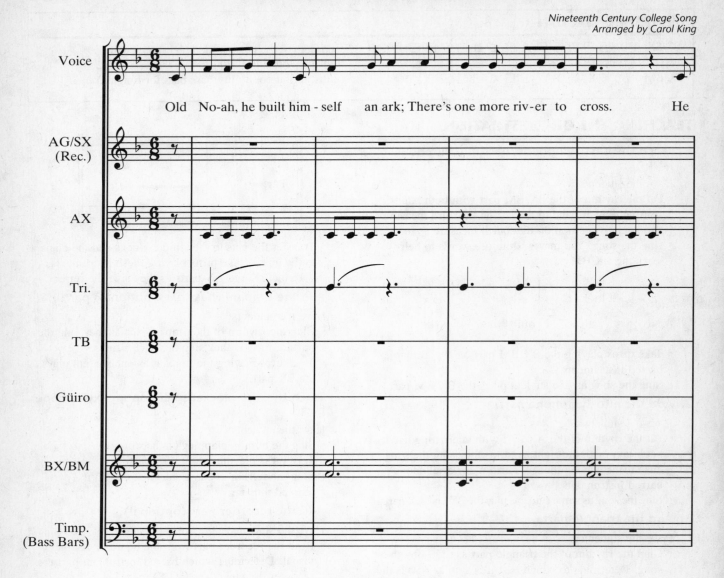

Old No-ah, he built him-self an ark; There's one more riv-er to cross. He

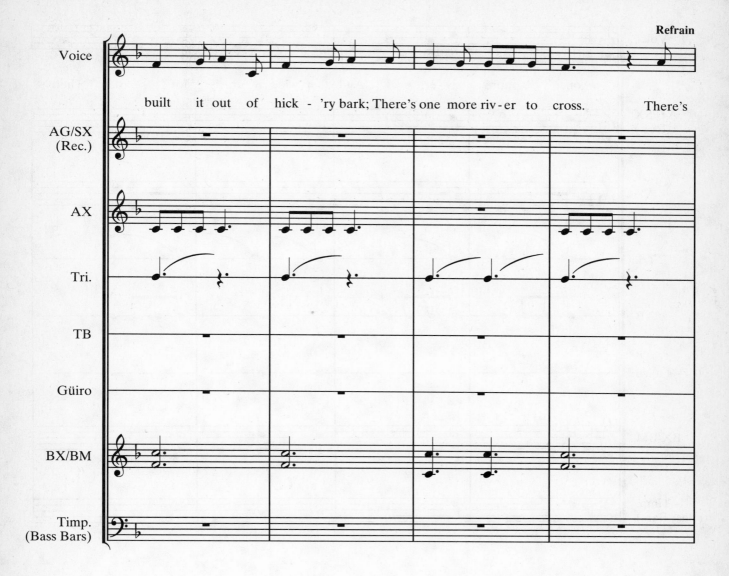

built it out of hick - 'ry bark; There's one more riv-er to cross. There's

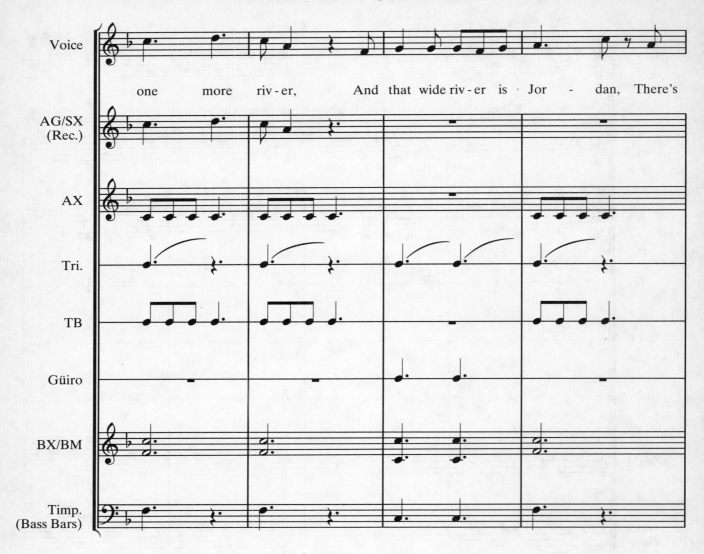

one more riv-er, And that wide riv-er is Jor - dan, There's

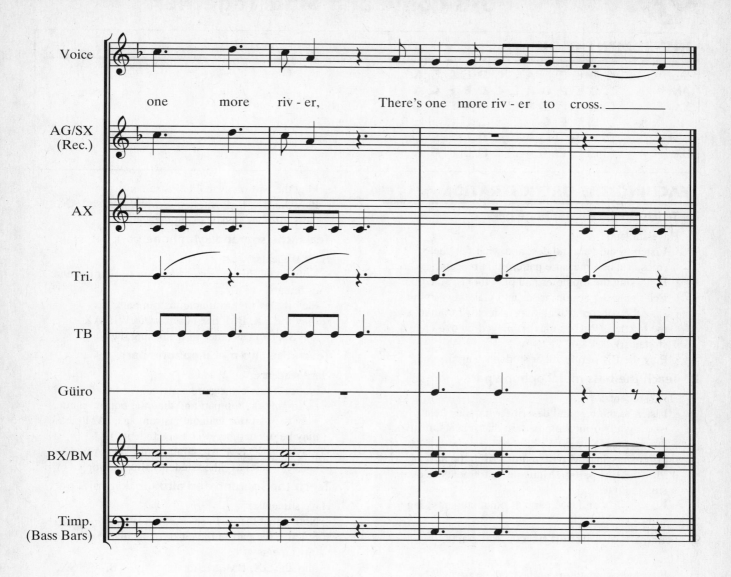

one more riv - er, There's one more riv - er to cross. _____

0·8 Come and Sing Together

INSTRUMENTATION

```
SG/AG   C D □ □ □ A □ C D □ □ □ A
AM      □ D □ F G A □ C D E F G A
SX      □ □ □ □ □ A □ □ D E F □ □
AX      □ □ E F G A □ □ □ □ □ □ □
BM      □ D □ □ □ A □ C D □ F □ □
BX      □ □ □ □ □ A □ C D □ □ G A
```

TEACHING THE ORCHESTRATION

1. Teach the bass xylophone part.

Have students:
- Listen to the part and describe what they hear. (mostly a one-measure pattern that repeats)
- Echo-sing the top notes and play them in the air.
- Echo-sing the bottom notes and play them in the air.
- Play the part on available instruments as others sing the pitches. (Pitches may be played by one or two students.)
- Play the BX part as other students sing the song.

2. Teach the bass metallophone part.

Have students:
- Listen to the part and describe what they hear. (mostly a two-measure pattern that repeats; it fits during the BX rests)
- Echo-sing the BM part and play it in the air.
- Play the BM part on available instruments as others sing the pitches.
- Play the BX and BM parts as other students sing the song.

3. Teach the unpitched percussion parts.

Have students:
- Find the two patterns in the triangle part.
- Tap the triangle part.
- Find the two patterns in the tambourine part. Tap the tambourine part, shaking the hand during measures 5–8.
- Find the pattern in the whip/wood block part. Tap the whip/wood block part.
- Play the three unpitched parts together.
- Play the BX, BM, tri., tamb., and whip/WB parts as other students sing the song.

4. Teach the alto xylophone part.

Have students:
- Notice that the part is mostly a one-measure pattern.
- Practice the pattern in the air, noticing that both hands play for the first eighth and only the right hand plays for the second eighth.
- Play the part on available instruments.
- Play the BX, BM, tri., tamb., whip/WB, and AX parts as other students sing the song.

5. Teach the soprano xylophone part.

Have students:
- Notice that the three measures are similar but end differently.
- Play the part on available instruments.
- Play the BX, BM, tri., tamb., whip/WB, AX, and SX parts as other students sing the song.

6. Teach the alto metallophone part.

Have students:
- Notice the two-measure pattern.
- Echo-sing the top part and then the bottom part.
- Play the part on available instruments. (AM part may be divided between two students.)
- Play the BX, BM, tri., tamb., whip/WB, AX, SX, and AM parts as other students sing the song.

7. Teach the soprano and alto glockenspiel part.

Have students:
- Notice that the part uses octave leaps.
- Practice the part in the air or on available instruments.
- Play the BX, BM, tri., tamb., whip/WB, AX, SX, AM, and SG/AG parts as other students sing the song.

FORM

Verse: Voice, SG/AG, AM, SX, AX, Tri., Tamb., Whip/WB, BM, BX

NOTEWORTHY

Rhythm: eighth notes, quarter notes, half notes
Melody: D minor

0·8 Come and Sing Together

Hungarian Melody
Arranged by Marilyn Copeland Davidson

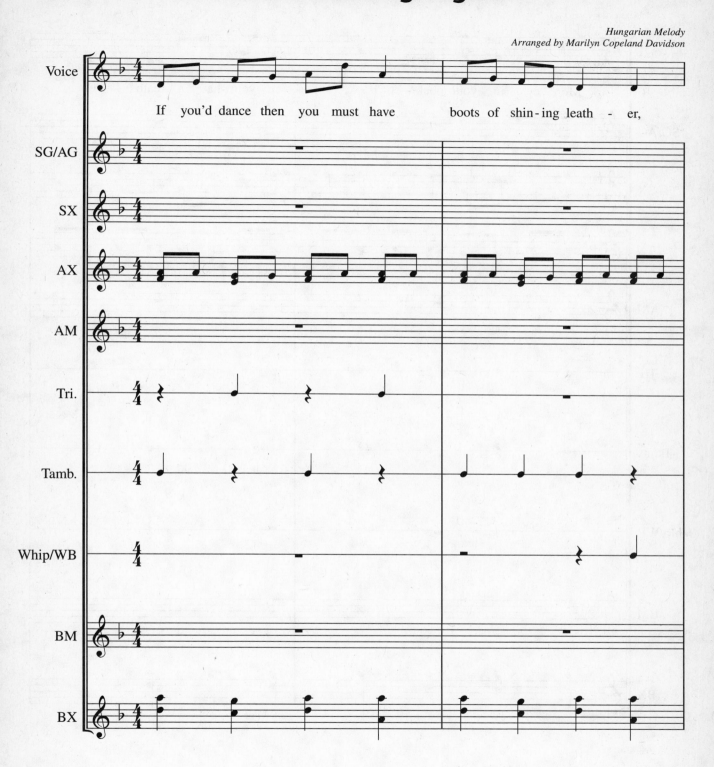

If you'd dance then you must have boots of shin-ing leath - er,

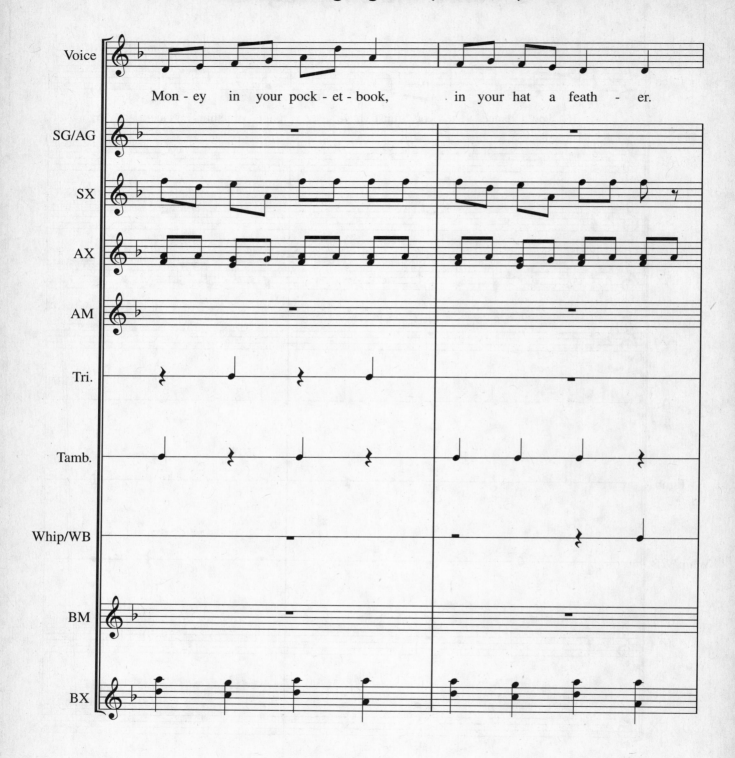

Mon - ey in your pock - et - book, in your hat a feath - er.

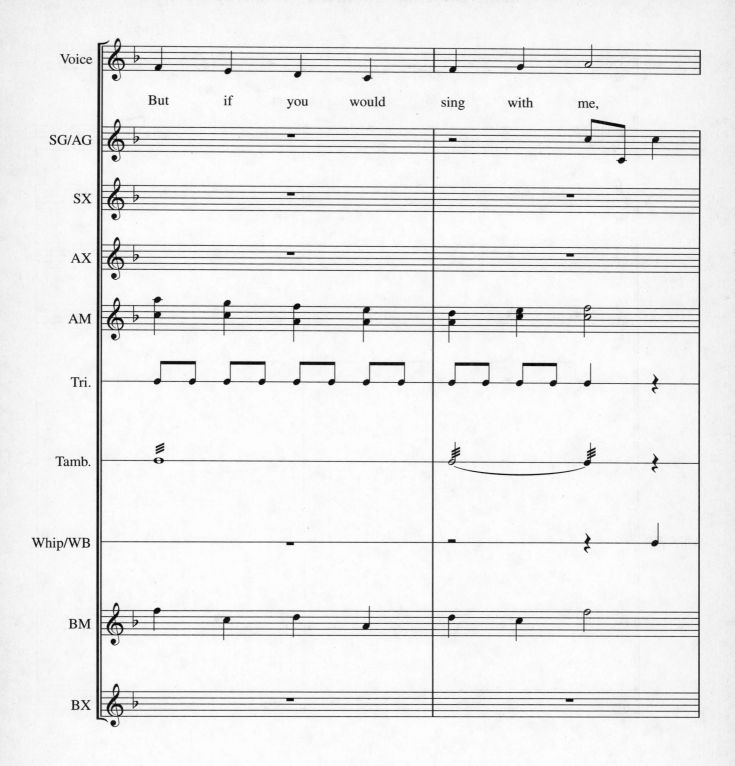

But if you would sing with me,

Come and Sing Together (continued)

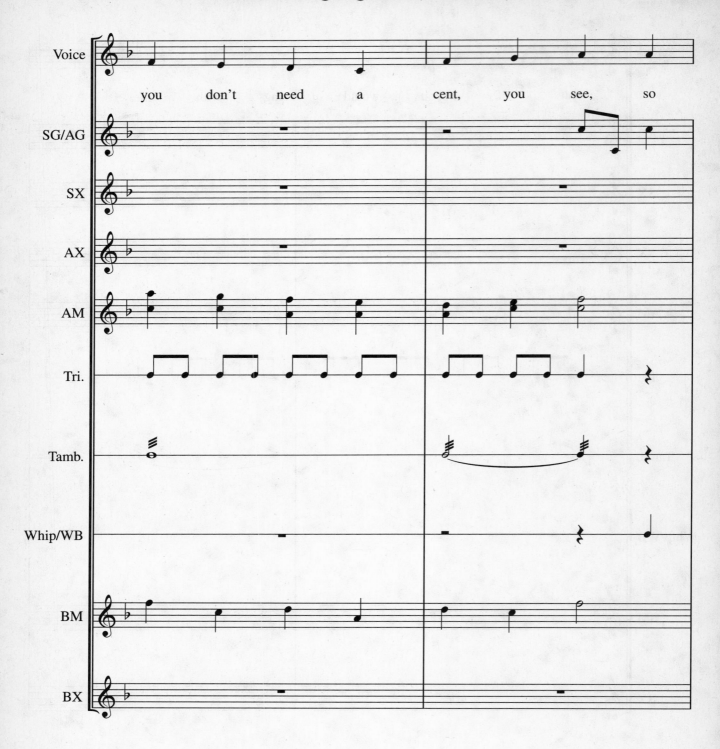

you don't need a cent, you see, so

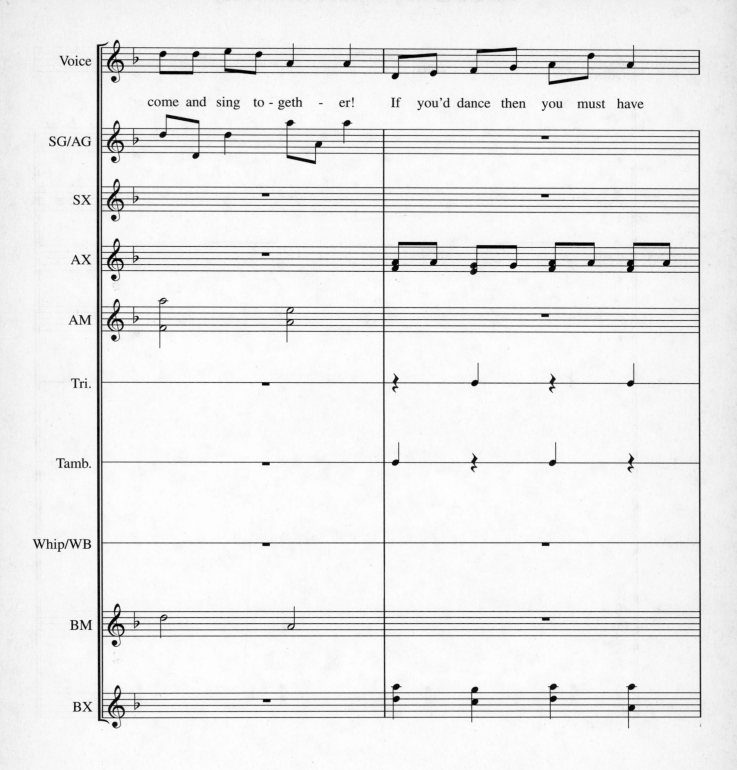

come and sing to-geth - er! If you'd dance then you must have

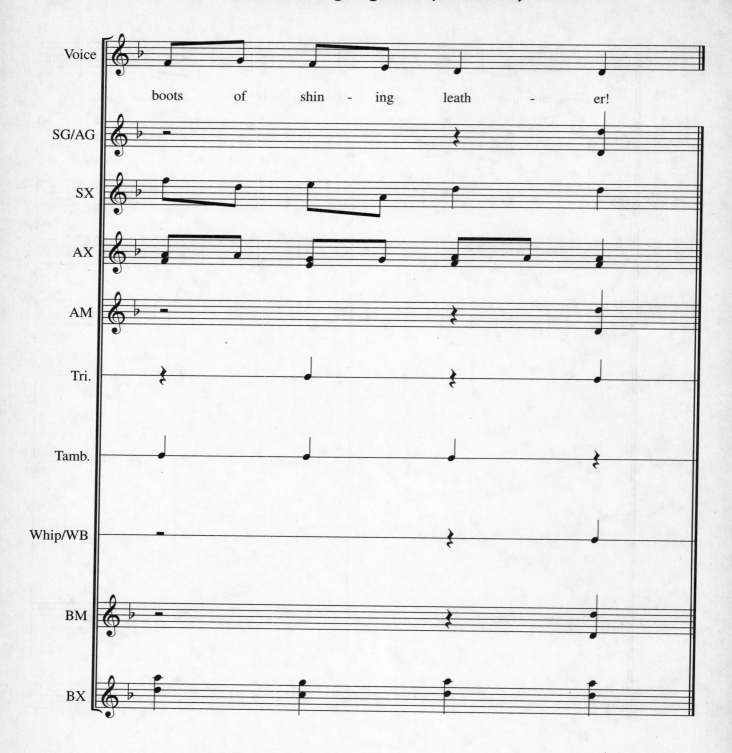

boots of shin - ing leath - er!

TEACHER'S NOTES

0·9 Hosanna, Me Build a House

INSTRUMENTATION

SG/SM/BM	**C**	**D**	□	□	□	□	□	**C**	**D**	□	□	□	□		
AG/AM	□	□	□	□	□	**A**	**B**	**C**	**D**	**E**	□	□	□		
SX	**C**	□	□	□	**G**	□	□	**C**	□	□	□	□			
AX	**C**	□	**E**	□	**G**	**A**	□	□	□	□	□	□			
BX	**C**	□	□	**F**	**G**	**A**	□	**C**	□	□	□	□			

claves, maracas, bongo drums, güiro, conga drum, timpani (opt.)—tuned to F, G, and C

(Substitution possibility: timpani for bass bars)

TEACHING THE ORCHESTRATION

1. **Teach the bass xylophone part in the A section.**

 Have the students:
 - Sing the A section as they pat the rhythm of the words and then as they sing the pitch names of the BX part.
 - Take turns playing the BX part on any available barred instrument.
 - Sing the A section as one student plays the BX part.

2. **Teach the soprano xylophone and alto xylophone parts in the A section.**

 Have the students:
 - Sing the A section as they clap on the word *hosanna* and then as they sing the pitch names of the SX and AX parts.
 - Take turns playing the SX and AX parts on any available barred instruments.
 - Sing the A section as some students play the BX, AX, and SX parts.

3. **Teach the alto xylophone and bass xylophone parts in the B section.**

 Have the students:
 - Echo-pat the following rhythm and then form two groups and perform the rhythm in canon:

 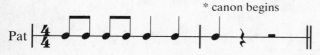

 - Continue patting in canon, singing the pitch names of each part. This may be shown on the board or another visual.
 - Take turns playing the BX and AX parts on any available barred instruments.
 - Sing the B section as some students play the BX and AX parts.

4. **Add the alto glockenspiel/alto metallophone part in the B section.**

 Have the students:
 - Clap the rhythm of the AG/AM part as they sing the B section and then as they sing the pitch names.
 - Take turns playing the AG/AM part on any available barred instruments.
 - Combine the AG/AM part with the BX and AX parts as they sing the B section.

5. **Teach the maracas and conga drum parts in the B section.**

 Have the students:
 - Echo the following rhythm patterns:

 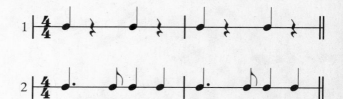

 - Transfer the first pattern to the maracas and the second pattern to the conga drum.
 Note: Play the first beat of the conga drum rhythm in the center of the drum head and the following notes near the rim of the drum head. Take turns playing these parts with the other parts previously learned.

6. **Add the bass bars (timpani, optional) part in the B section.**

 Have the students:
 - Sing the B section as they clap on the first beat of every measure.
 - Take turns playing the part as they sing the B section and then combine with the other instruments.

7. **Teach the claves/bongo drums part in the C section.**

 Have the students:
 - Sing the C section, clapping on all the words except *ha ha*.
 - Take turns playing the rhythm of the words on the claves or bongo drums as they sing the C section.

8. **Add the soprano glockenspiel/soprano metallophone/bass metallophone and güiro parts in the C section.**

Have the students:
- Sing the C section, patting on the words *ha ha*.
- Take turns playing the SG/SM/BM parts on any available barred instruments and then with the claves/bongo drums part as they sing the C section.
- Perform the entire orchestration as written.

FORM

A section:	Voice, SX, AX, BX
B section:	Voice, AG, AX, BX, AM, Bass Bars, Timp. (opt.), Conga, Mar.
C section:	Voice, SG/SM/BM, Clvs., Bongo, Güiro
Coda:	Voice, SX, AX, BX

NOTEWORTHY

Rhythm:	syncopation
Melody:	C major
Harmony:	I-IV-V

0·9 Hosanna, Me Build a House

Jamaican Calypso
Arranged by Carol King

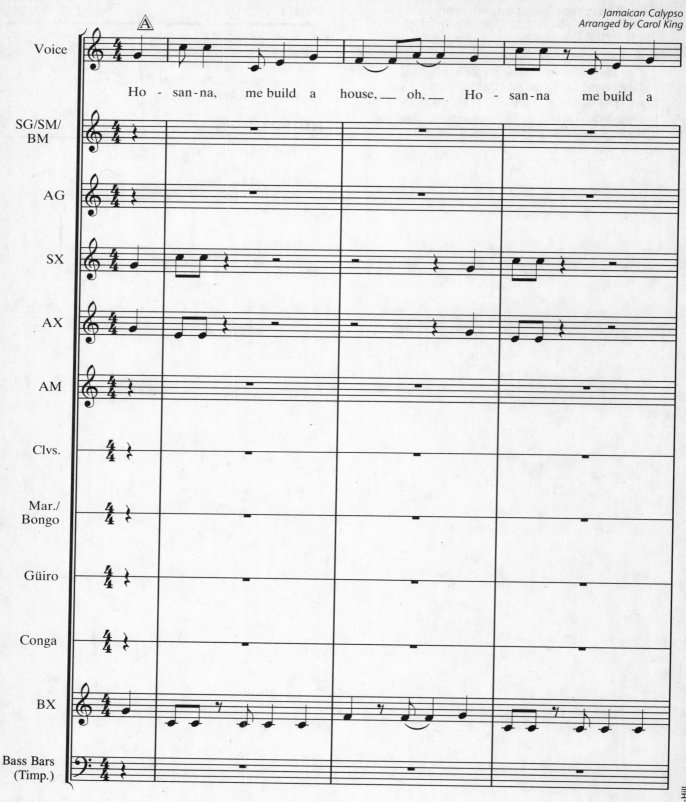

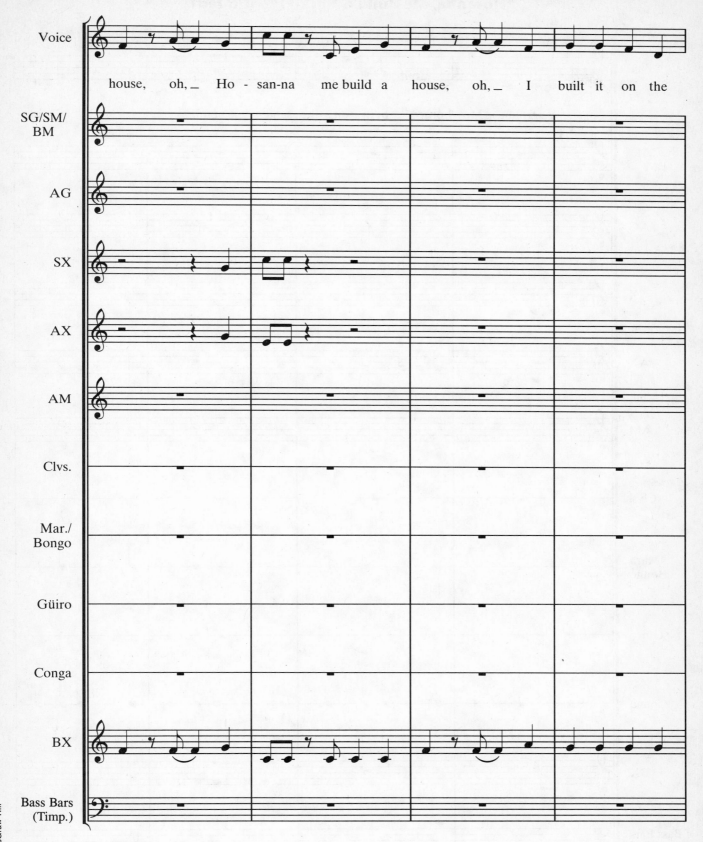

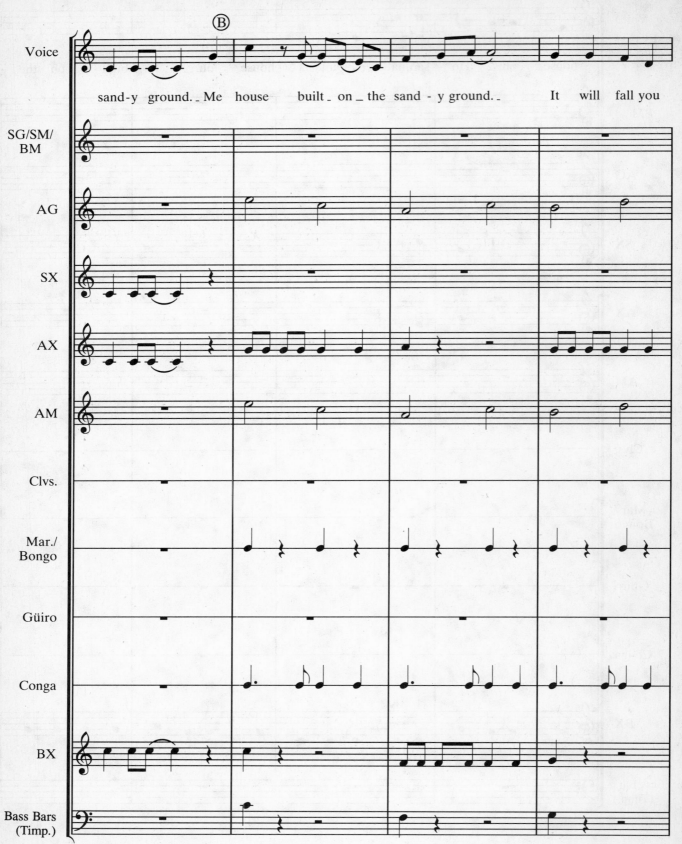

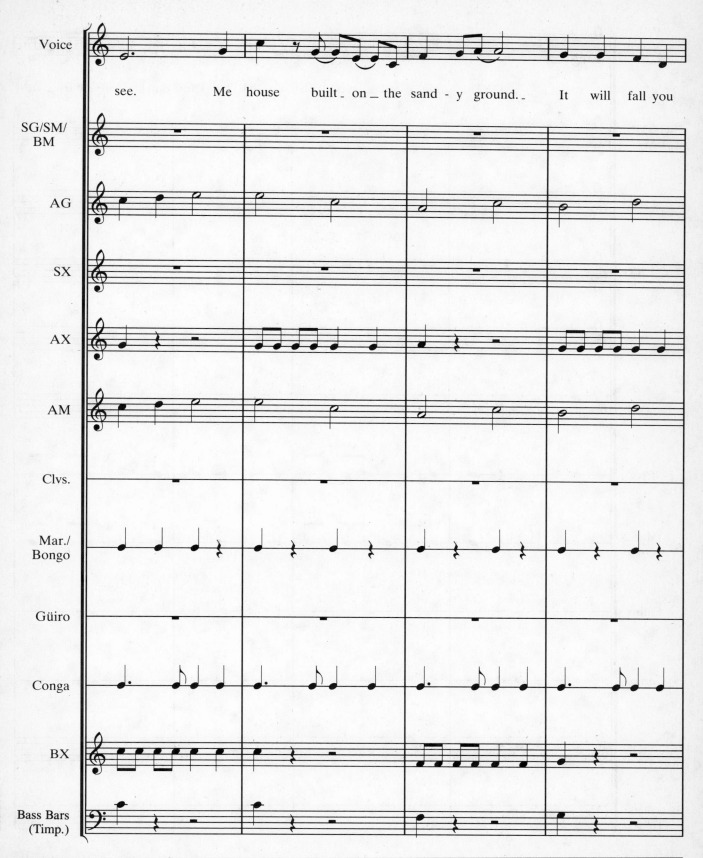

see. Me house built _ on _ the sand - y ground. _ It will fall you

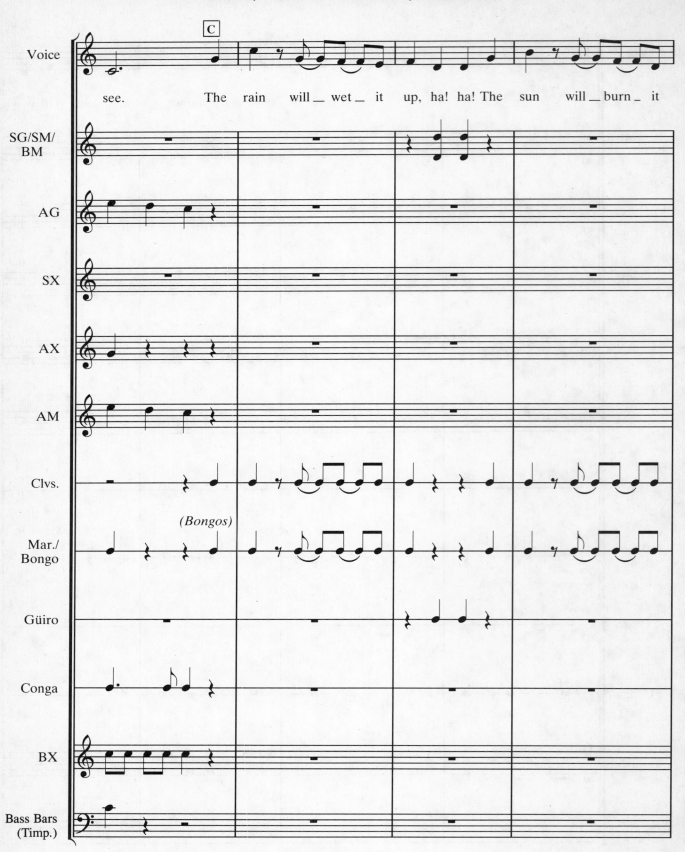

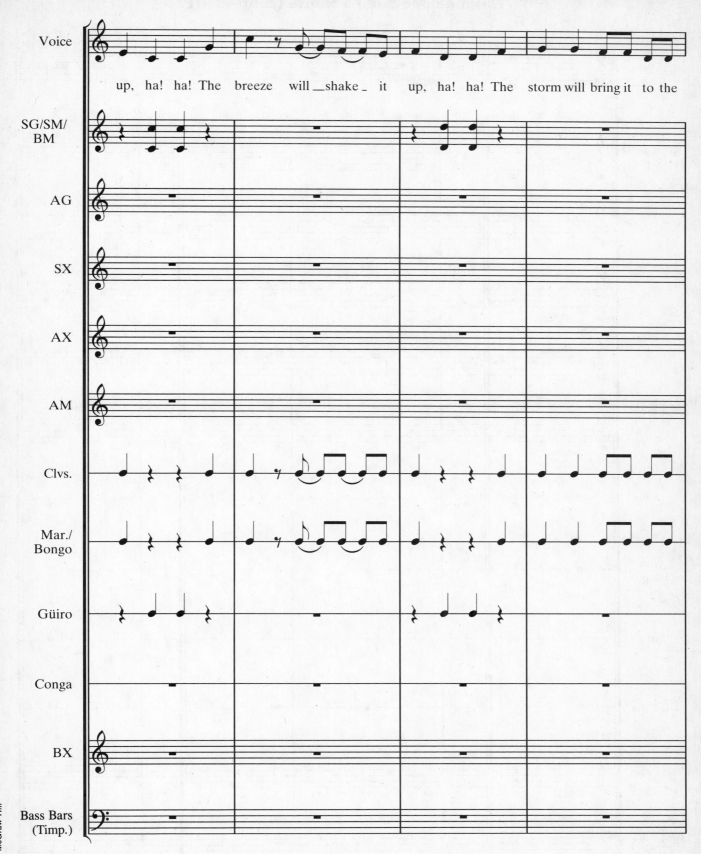

Hosanna, Me Build a House (continued)

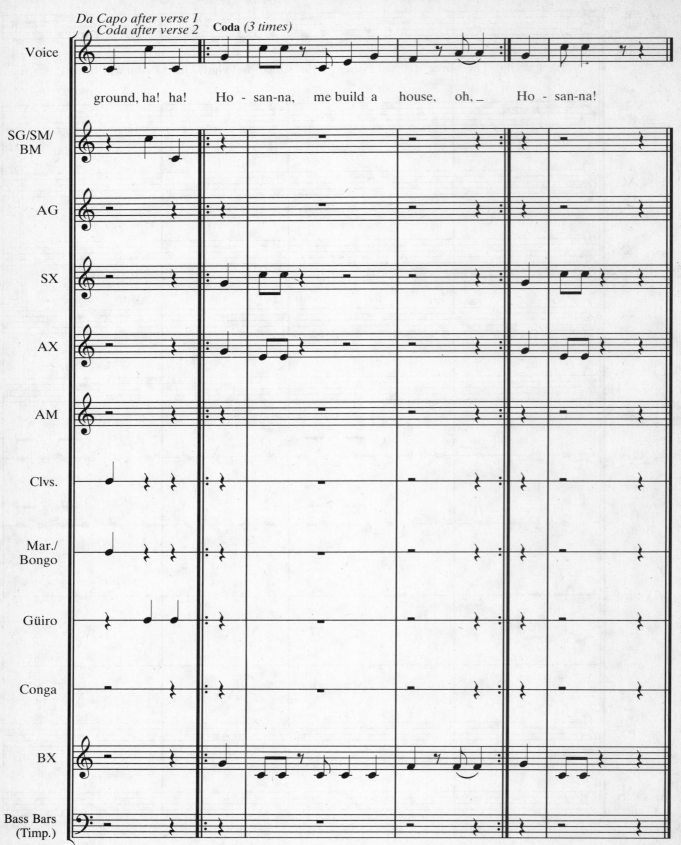

ground, ha! ha! Ho - san-na, me build a house, oh, _ Ho - san-na!

0·10 Little David, Play on Your Harp

INSTRUMENTATION

SG/AG	□	□	□	**F**	□	□	□	□	□	**F**	□	□	
AX	□	□	□	**F**	**G**	**A**	□	**C**	**D**	□	□	□	□
AM	□	□	□	**F**	□	□	□	□	□	□	**F**	□	□
BX	□	□	□	**F**	□	□	□	**C**	**D**	□	**F**	□	□

tambourine, wind chimes
(Substitution possibility: chime tree for wind chimes)

TEACHING THE INSTRUMENTATION

1. Teach the bass xylophone part in the refrain.

Have the students:

· Pat the rhythm of the BX part using alternating hands, beginning with the left hand, as they sing the refrain.

· Practice the cross-over pattern by mirroring you as they pat the following pattern: left-right-left-right-left-right-cross-right (cross: hitting the right side of the right knee with the left hand). Have them sing the refrain as they mirror you.

· Continue patting the rhythm as they sing the pitch names of the BX part.

· Take turns playing the BX part on any available barred instruments.

· Sing the song as one student plays the BX part.

2. Add the alto xylophone and tambourine parts in the refrain.

Have the students:

· Sing the refrain, clapping on the words *Hallelu! Hallelu!*

· Take turns playing the tambourine on the rhythm of the words *Hallelu! Hallelu!* as they sing the refrain.

· Clap the rhythm of *Hallelu, Hallelu* as they sing the pitch names of the AX part in the refrain.

· Practice playing the melody of the words *Hallelu! Hallelu!* on any available barred instrument. Then play it on the AX only.

· Sing the refrain with all the instruments learned thus far.

3. Teach the alto metallophone part in the refrain.

Have the students:

· Sing the refrain, patting both hands on the knees on the word *play*.

· Take turns playing the AM part on any available barred instrument.

· Sing the refrain as some students play the BX and AM parts.

4. Add the soprano glockenspiel/alto glockenspiel and wind chimes parts in the refrain.

Have the students:

· Practice playing a glissando on any barred instrument by striking the F and sliding the mallet quickly across the bars to the F¹.

· Take turns playing the glissando on any available barred instrument on the same beat with some students playing the AM part. Have students recall on which word of the song these parts play. (*Play*)

· Take turns playing the wind chimes along with the SG/AG glissandos.

· Sing the refrain as some students play all the instrumental parts.

5. Teach the bass xylophone part in the verse.

Have the students:

· Mirror you as you show a tremolo with your hands on one knee. (You may choose to have the students play the F tremolo in another way: holding two mallets in one hand, handles touching together in the palm making a "V" shape, one mallet over the end of the metallophone bar and one mallet underneath the bar, moving the hand quickly up and down.)

· Take turns playing the F tremolos on any available barred instruments.

· Sing the verse as one student plays the BX part.

FORM

Refrain:	Voice, SG/AG, AX, AM, BX, Tamb., W. Ch.
Verse:	Voice, BX
Refrain:	Same as above
Verse:	Same as above
Refrain:	Same as above

NOTEWORTHY

Rhythm:	syncopation
Melody:	Pentatonic

0·10 Little David, Play on Your Harp

African American Spiritual
Arranged by Carol King

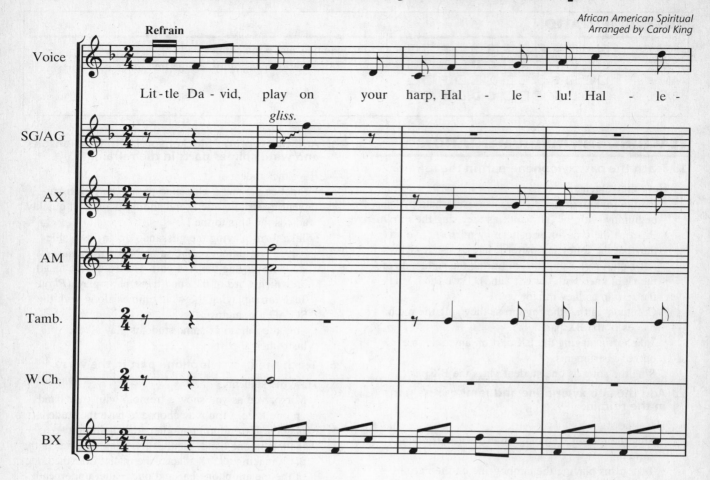

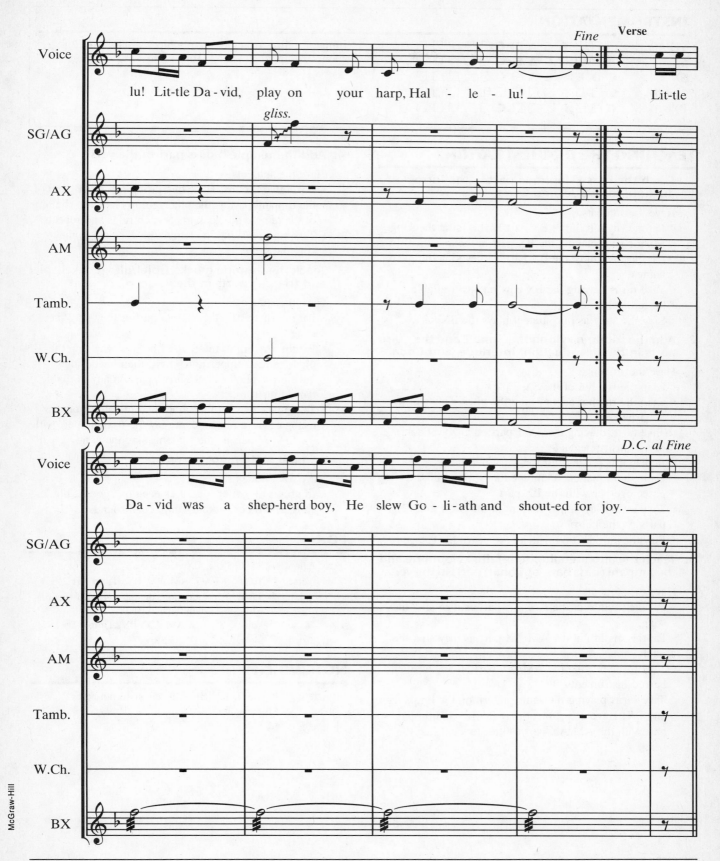

0·11 Sourwood Mountain

INSTRUMENTATION

SG/AG	☐	☐	☐	**F**	**G**	**A**	**B♭**	**C**	☐	☐	☐	☐	☐		
SX 1	☐	☐	☐	**F**	**G**	**A**	**B♭**	**C**	☐	☐	☐	☐	☐		
SX 2	**C**	**D**	**E**	**F**	**G**	**A**	☐	☐	☐	☐	☐	☐	☐		
AX/AM	**C**	☐	☐	**F**	☐	☐	☐	☐	☐	☐	☐	☐	☐		
BX	**C**	☐	☐	**F**	☐	☐	☐	**C**	☐	☐	☐	☐	☐		

timpani, güiro, triangle, temple blocks, bass bars (opt.), "found" unpitched sounds (opt.)

TEACHING THE ORCHESTRATION

1. Teach the bass xylophone part in the Introduction, Interlude, and Coda.

Have the students:
- Pat the rhythm of the BX part as they sing the song.
- Mirror you, playing the BX part in the air.
- Pat the rhythm of the BX part as they sing the pitch names.
- Take turns playing the BX part on any available barred instruments.
- Sing the song as one student plays the BX part.

2. Add the soprano xylophone 1 and 2 and the güiro parts in the Introduction, Interlude, and Coda.

Have the students:
- Clap the rhythm of the SX 1 part.
- Clap the rhythm as they sing the pitch names of the SX 1 part.
- Take turns playing the SX 1 part on any available barred instrument.
- Repeat this process for the SX 2 part.
- Using hard mallets, combine the SX 1 and SX 2 parts together with the BX part.
- Take turns playing the rhythm of the SX 1 and SX 2 parts on the güiro.
- Play the introduction with all the instruments together.

3. Teach the alto metallophone/alto xylophone and the timpani (bass bars, optional) parts in the verse.

Have the students:
- Pat the rhythm of the AM/AX part as they sing the song.
- Pat the rhythm of the AM/AX part as they sing the pitch names.
- Take turns playing the AM/AX part on any available barred instruments.
- Take turns playing the same pattern on the timpani and BX. Have one student play the BX and timpani part with the AM/AX part as the students sing the song.

4. Add the temple blocks part in the verse.

Have the students:
- Form two groups. Have one group pat the rhythm of the timpani part as the other group claps the rhythm of the temple blocks part. Switch roles and repeat.
- Take turns playing the temple blocks part as they sing the song.

5. Teach the soprano glockenspiel/alto glockenspiel and triangle parts in the verse.

Have the students:
- Pat the rhythm of the SG/AG part as they sing the song.
- Pat the rhythm of the SG/AG part as they sing the pitch names—upper notes first, then lower notes.
- Take turns playing the SG/AG part on any available barred instruments.
- Take turns playing the same rhythm pattern on the triangle. Have one student play the triangle part with the SG/AG part as the students sing the song.

6. Add a B section. (optional)

Have four students:
- Improvise for four measures each on spoons, bottles, cans, and other "found" unpitched sounds.

FORM

Introduction:	SX 1, SX 2, BX, Güiro
Verse:	Voice, SG/AG, AM/AX, BX, Timp., Tri., TB
B section:	Same as introduction, or improvised B section with "found" unpitched sounds
Verse:	Voices, SG/AG, AM/AX, BX, Timp., Tri., TB
Coda:	SX 1, SX 2, BX, Güiro

NOTEWORTHY

Rhythm:	quarter notes, eighth notes, sixteenth notes
Melody:	F pentatonic
Harmony:	I-V

0·11 Sourwood Mountain

Appalachian Folk Song
Arranged by Carol King and Nancy Ferguson

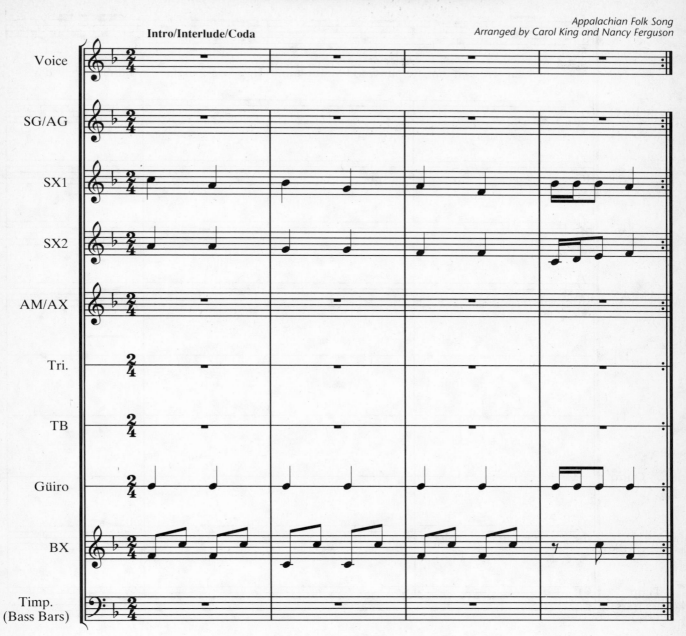

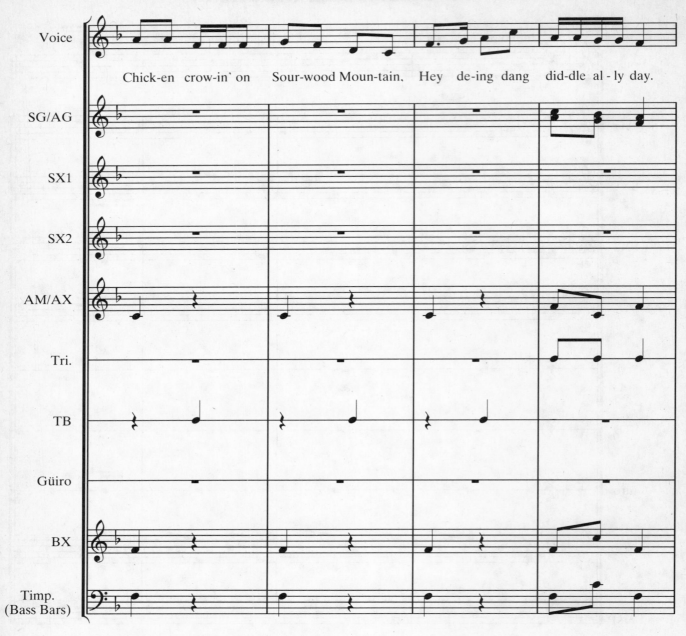

Chick-en crow-in' on Sour-wood Moun-tain, Hey de-ing dang did-dle al - ly day.

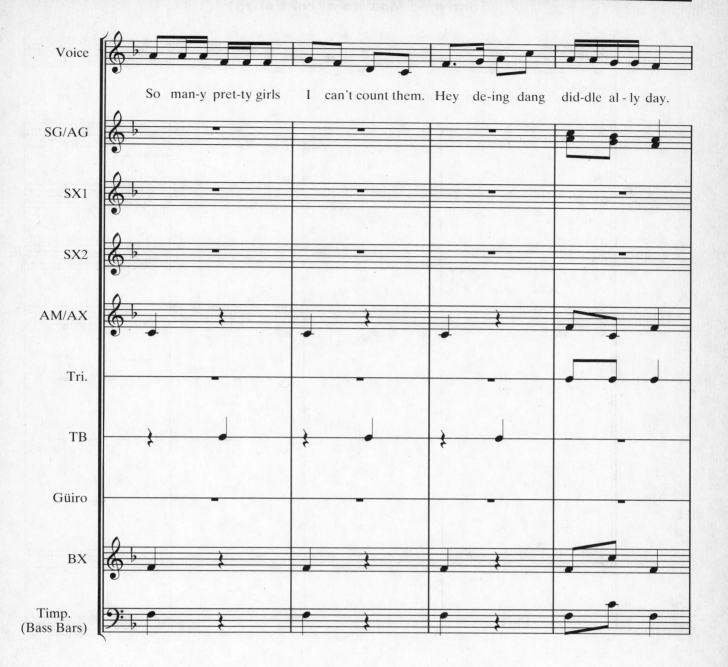

So man-y pret-ty girls I can't count them. Hey de-ing dang did-dle al - ly day.

Sourwood Mountain (continued)

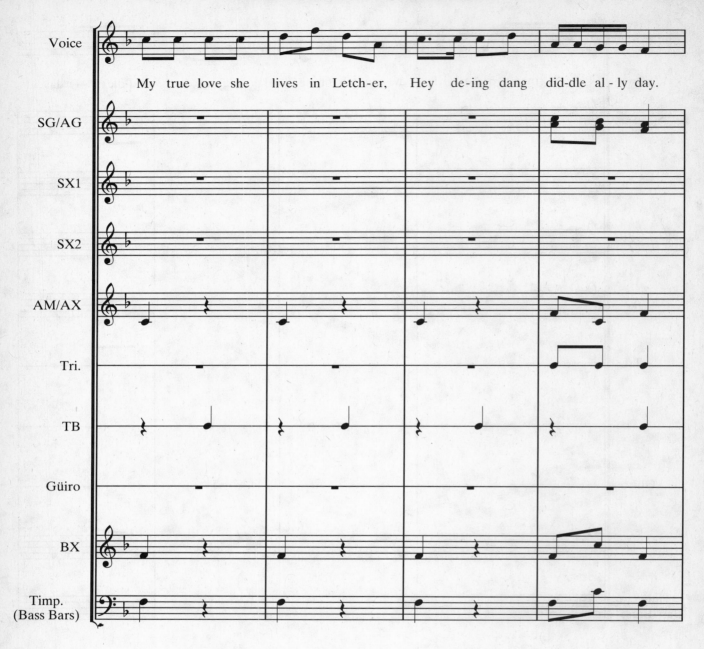

McGraw-Hill

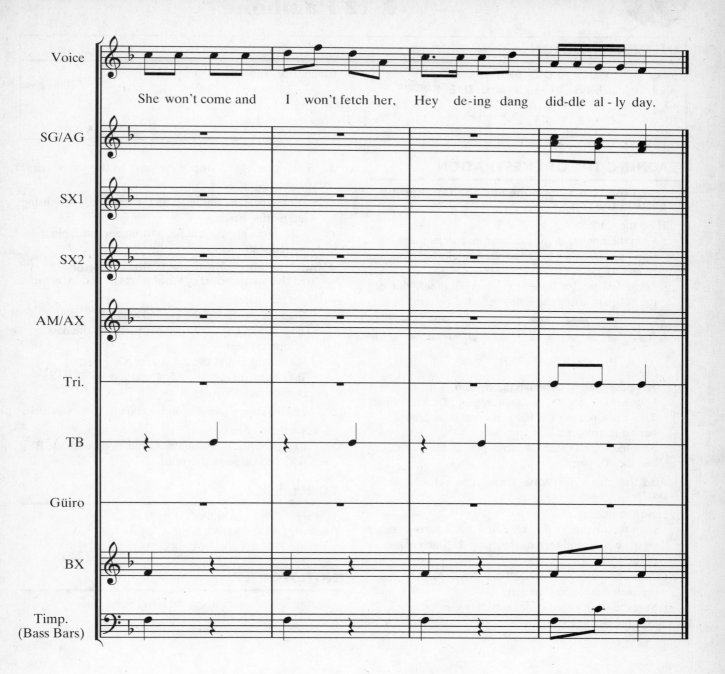

She won't come and I won't fetch her, Hey de-ing dang did-dle al - ly day.

0·12 Hambone

INSTRUMENTATION

SX	□ □ □ □ G □ B♭ C D □ F G □
AX 1	□ □ □ □ □ □ B♭ B C D E F □
AX 2	□ □ E F G A □ □ □ □ □ □ □
BX	C D E F G □ □ □ □ □ □ □ □

tambourine, suspended cymbal

TEACHING THE ORCHESTRATION

1. **Teach the bass xylophone and the tambourine parts in the song.**

 Have the students:
 - Clap the rhythm of the tambourine part as they sing the song. Decide what beats the tambourine plays on (2 and 4).
 - Form two groups. Have one group pat the rhythm of the BX part, using the following hand pattern:

 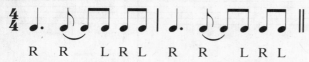

 R R L R L R R L R L

 Have the other group clap the rhythm of the tambourine part. Switch roles and repeat. Then combine.
 - Take turns playing the BX part on any available barred instruments.
 - Sing the song as some students play the tambourine and the BX parts.

2. **Add the alto xylophone 1 and alto xylophone 2 parts.**

 Have the students:
 - Clap the rhythm of the AX 1 and AX 2 parts as they sing the song and then as they sing the pitch names of the parts.
 - Take turns playing the AX 1 and AX 2 parts on any available barred instruments.
 - Sing the song as some students play the AX 1, AX 2, tambourine, and BX parts.

3. **Teach the bass xylophone part in the interlude.**

 Have the students:
 - Pat the beat, beginning with the left hand, then using alternating hands.
 - Take turns playing the BX part on any available barred instruments.

4. **Add the alto xylophone 1, alto xylophone 2, and the suspended cymbal parts in the interlude.**

 Have the students:
 - Clap the rhythm of the cymbal part.
 - Take turns playing the cymbal part with the bass xylophone part.
 - Pat the rhythm of the AX 1 and AX 2 parts.
 - Take turns playing the AX 1 and 2 parts with the cymbal and BX parts.

5. **Add the soprano xylophone part in the interlude.**

 Have the students:
 - Improvise melodies one at a time along with the BX, AX, and suspended cymbal.

FORM

Song:	Voice, AX1, AX2, BX, Tamb.
Interlude:	SX, AX1, AX2, BX, S. Cym.
Song:	Voice, AX1, AX2, BX, Tamb.

NOTEWORTHY

Rhythm:	syncopation, quarter notes, eighth notes

0·12 Hambone

African American Hand Jive
Arranged by Doug Goodkin

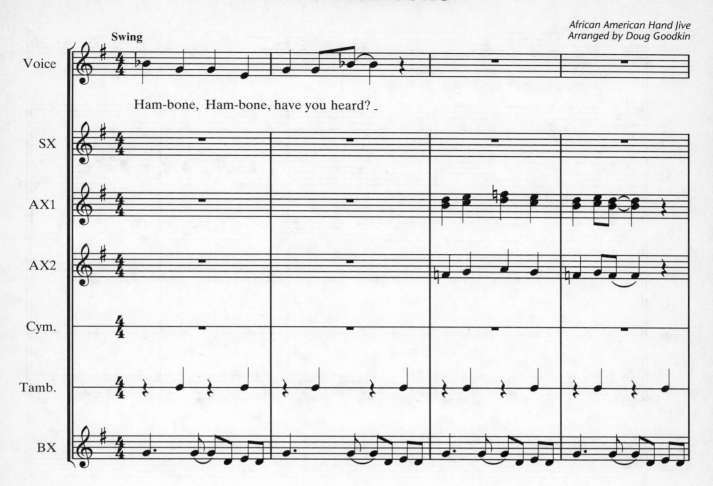

Ham-bone, Ham-bone, have you heard?

Hambone (continued)

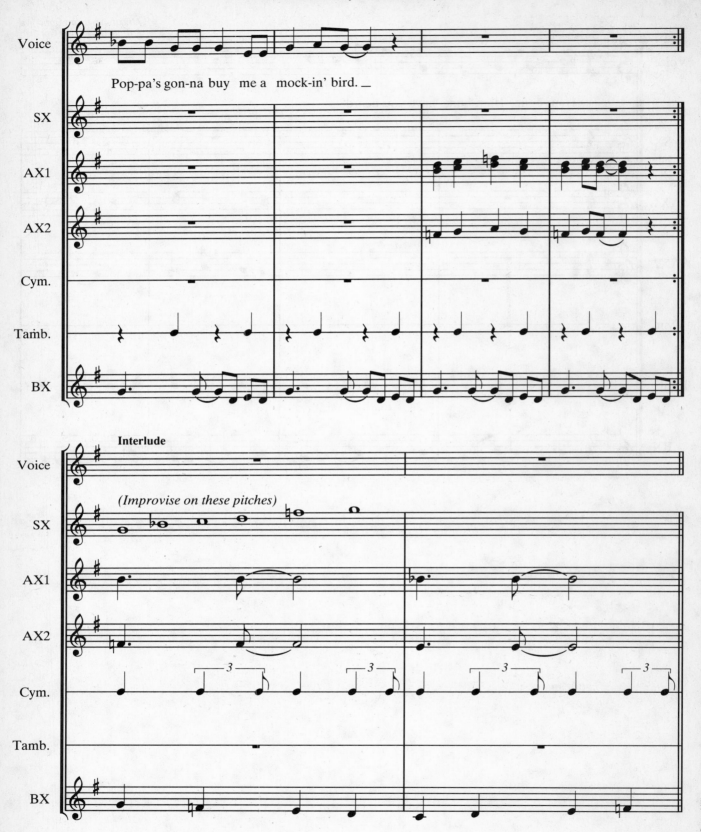

Pop-pa's gon-na buy me a mock-in' bird. _

Interlude

(Improvise on these pitches)

McGraw-Hill

0·13 Old Joe Clark

INSTRUMENTATION

SG	C □ □ □ □ □ C □ □ □ □ □		
SX	C □ □ □ □ □ □ □ □ □ □ □		
AG/AX	□ □ □ F □ □ □ □ □ □ F □ □		
BX/BM	C □ □ F □ □ □ C □ □ □ □ □		

woodblock, güiro
(Doubling possibility: tin can or bottle may double the rhythm of the SG part)

TEACHING THE ORCHESTRATION

1. Teach the bass xylophone part in the refrain.

Have the students:

- Mirror you as they pat the rhythm of the BX part, using alternating hands while they sing the song. Determine where the bass part needs to change to accommodate the melody. (on the words *round I say* and *long to stay*)
- Continue patting the rhythm as they sing the pitch names of the BX part.
- Take turns playing the BX part on any available barred instruments.
- Sing the refrain as one student plays the BX part.

2. Add the soprano glockenspiel, soprano xylophone, woodblock, and güiro parts in the refrain.

Have the students:
- Perform the following body percussion as shown below. (You may have them read from the board or another visual.):

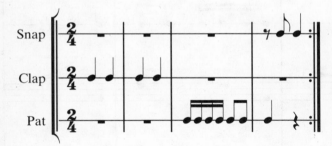

- Transfer the claps to the woodblock, the pats to the SX playing on C and the güiro, and the snaps to the SG playing C octaves. Take turns playing each part. Switch roles and repeat.
- Sing the refrain as some students play all the parts learned thus far.

3. Teach the bass xylophone/bass metallophone part in the verse.

Have the students:
- Pat the rhythm of the BX/BM part with both hands, shifting the left hand to the left side of the leg on the second quarter note (where appropriate), as they sing the verse.

- Take turns playing the BX/BM part on any available barred instruments.
- Sing the verse as one student plays the BX/BM part.

4. Add the alto glockenspiel and alto xylophone parts in the verse.

Have the students:
- Pat the rhythm of the AX part beginning with the left hand as shown below, while snapping the rhythm of the AG part.

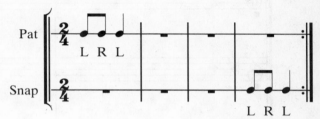

- Take turns playing the AX and AG parts on F octaves on any available barred instruments.
- Sing the verse as some students play the AX and AG parts combined with the BX/BM, woodblock, and güiro part.

FORM

Introduction:	First four measures of refrain accompaniment, SG, WB., Güiro, SX, BX
Refrain:	Voice, SG, SX, BX, WB, Güiro
Verse:	Voice, AG, AX, BX/BM, WB, Güiro
	Repeat with additional verses, finishing with a refrain.

NOTEWORTHY

Rhythm:	quarter note, eighth note, sixteenth note
Melody:	F Mixolydian
Harmony:	I-V

0·13 Old Joe Clark

American Folk Song
Arranged by Carol King

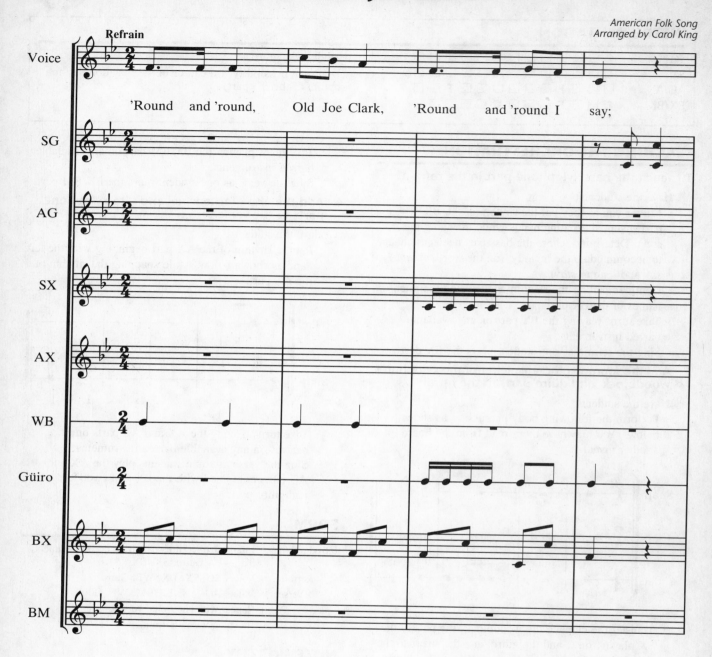

'Round and 'round, Old Joe Clark, 'Round and 'round I say;

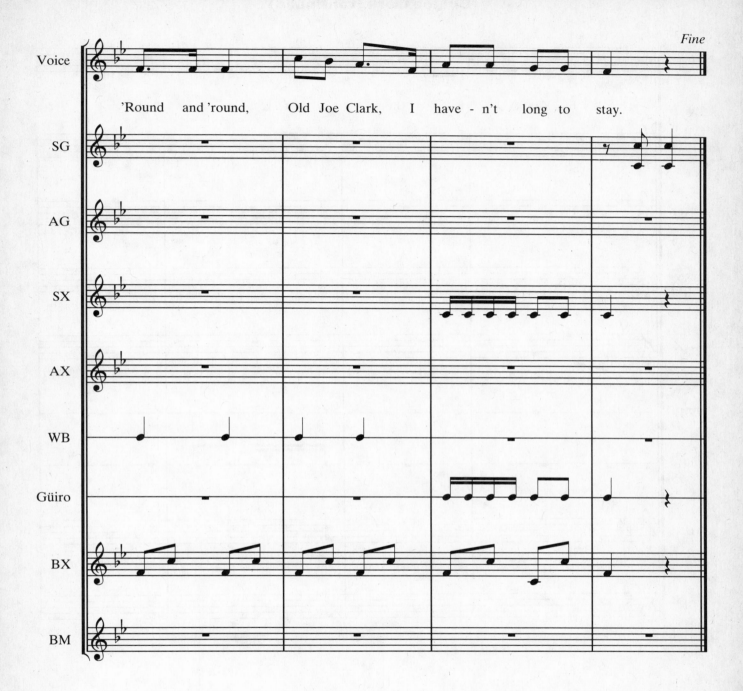

'Round and 'round, Old Joe Clark, I have - n't long to stay.

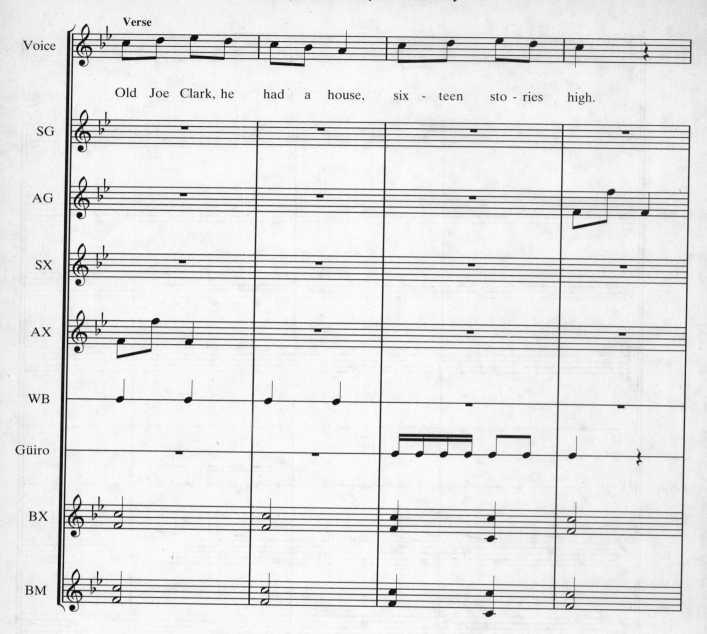

Old Joe Clark, he had a house, six - teen sto - ries high.

D.C. al Fine

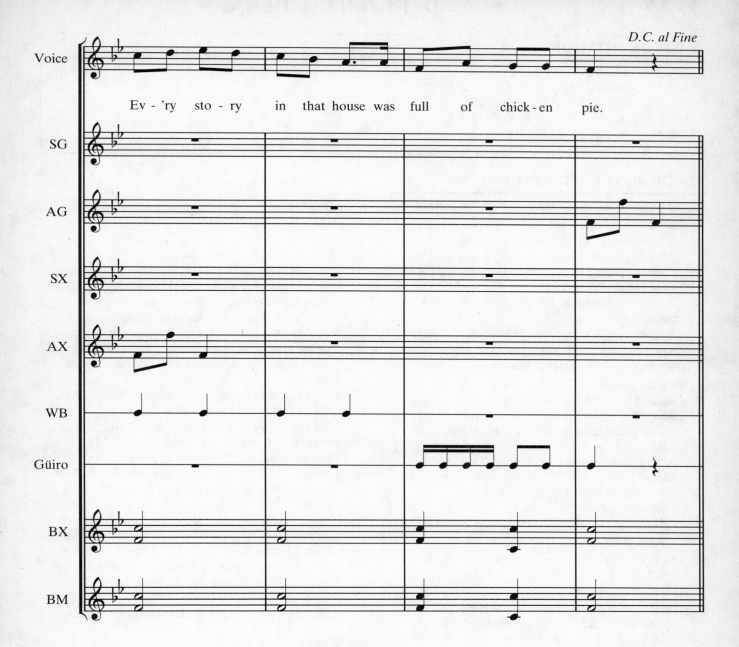

Ev - 'ry sto - ry in that house was full of chick - en pie.

0•14 Michie Banjo

INSTRUMENTATION

SG/AG	□	□	**E**	**F**	**G**	□	□	□	□	□	□	□	□	□
SX	**C**	□	□	**F**	□	□	□	**C**	□	□	**F**	□	□	
AX	**C**	□	□	**F**	□	□	□	□	□	□	□	□	□	
AM	**C**	□	□	**F**	**G**	**A**	**B♭**	**C**	□	□	□	□	□	
BX/BM	**C**	□	□	**F**	□	□	□	**C**	□	□	□	□	□	

claves, conga drum, triangle

TEACHING THE ORCHESTRATION

1. Teach the bass xylophone part in the refrain.

Have the students:
- Mirror you as they pat the rhythm of the BX part, using alternating hands while they sing the refrain.
- Continue patting the rhythm as they sing the pitch names of the BX part.
- Take turns playing the BX part on any available barred instruments.
- Sing the refrain as one student plays the BX part.

2. Teach the soprano xylophone and alto xylophone parts in the refrain.

Have the students:
- Reading from the board or another visual, look at the rhythm of the SX and AX parts. How are they similar? (The third measure of the AX part is the same as the first and second measure of the SX part.) Identify words in the refrain that have the same rhythm as the SX part. (*Look at Michie Banjo, fancy Michie Banjo.*)
- Take turns playing the SX part.
- Sing the refrain as some students play the BX, SX, and AX parts.

3. Add the conga drum and claves parts in the refrain.

Have the students:
- In one group pat the rhythm of the conga part as a second group claps the rhythm of the claves part, reading from the board or another visual. Switch roles and repeat.
- Practice playing the conga part, striking the dotted quarter note in the center of the drum head and the other notes near the rim.
- Add the claves part and play both parts with the BX part.
- Play the introduction: two measures of conga joined by two measures of the BX part, as indicated in the score. Then sing the refrain with all the instrumental parts.

4. Teach the bass metallophone, alto metallophone, and triangle parts in the verse.

Have the students:
- Clap the rhythm of the AM part as they sing the verse. Identify the words of the verse that fall on those beats. (*cha-, cocked, side, high, shoes, squeak*)

- Divide the AM part into three lines as shown below:

A	B♭	C
F	G	A
C	C	F

Assign each line to a different instrument; or have one student play all parts with three mallets, or have three students play the part on one instrument.
- Take turns playing the AM part on any available barred instrument. Have one student play the triangle in the same rhythm as the AM part.
- Review the BX part from Step 1. Transfer this part to the BM.
- Sing the verse as some students play the BM, AM, conga drum, and triangle parts.

5. Add the soprano glockenspiel/alto glockenspiel and claves parts in the verse.

Have the students:
- Sing the verse, clapping on the words *Michie Banjo* and snapping on the words *high button shoes that squeak*. Find the places in the song where these words recur.
- Transfer the rhythm of *Michie Banjo* to the claves and of *High button shoes that squeak* to the SG/AG part. Take turns playing these parts as they sing the verse and then as they sing the pitch names of the notes.
- Sing the verse as some students play all the parts.

FORM

Introduction:	Conga, BX
Refrain:	Voice, SX, AX, BX, Clvs., Conga
Verse 1:	Voice, SG/AG, AM, BM, Conga, Tri., Clvs.
Refrain:	Voice, SX, AX, BX, Clvs., Conga
Verse 2:	Voice, SG/AG, AM, BM, Conga, Tri., Clvs.
Refrain:	Voice, SX, AX, BX, Clvs., Conga
Coda:	SX, AX, BX, Conga, Clvs.

NOTEWORTHY

Rhythm:	syncopation
Melody:	F major
Harmony:	I-V

McGraw-Hill

0·14 Michie Banjo

Creole Bamboula
English Words by Margaret Marks
Arranged by Carol King

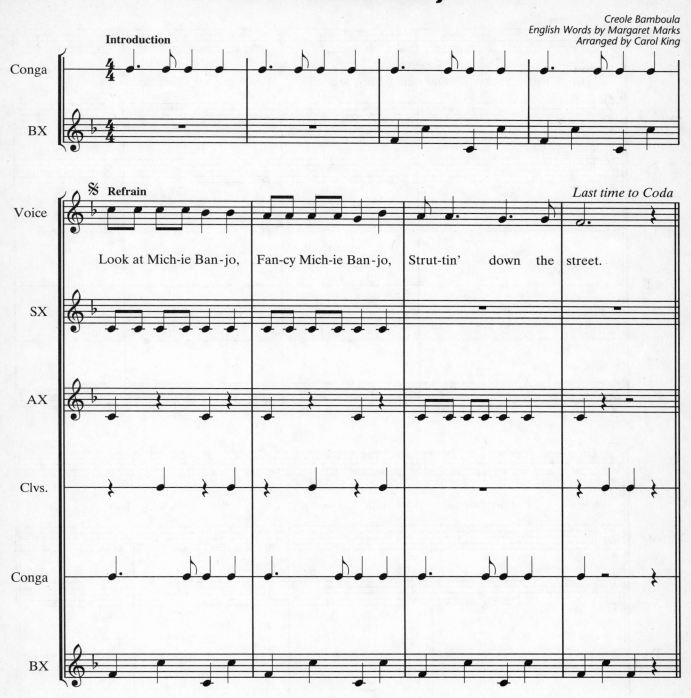

Look at Mich-ie Ban-jo, Fan-cy Mich-ie Ban-jo, Strut-tin' down the street.

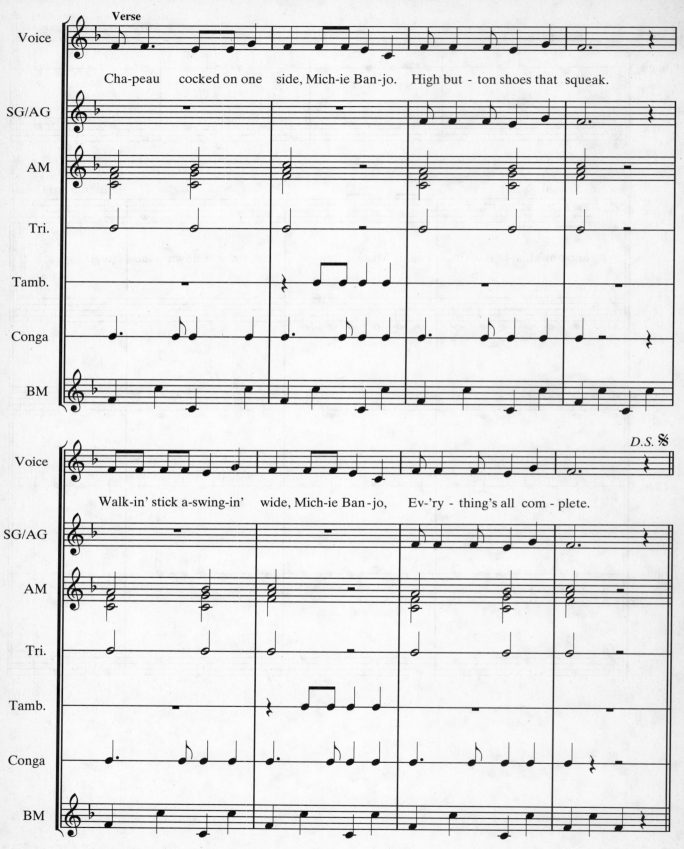

Cha-peau cocked on one side, Mich-ie Ban-jo. High but - ton shoes that squeak.

Walk-in' stick a-swing-in' wide, Mich-ie Ban - jo, Ev-'ry - thing's all com - plete.

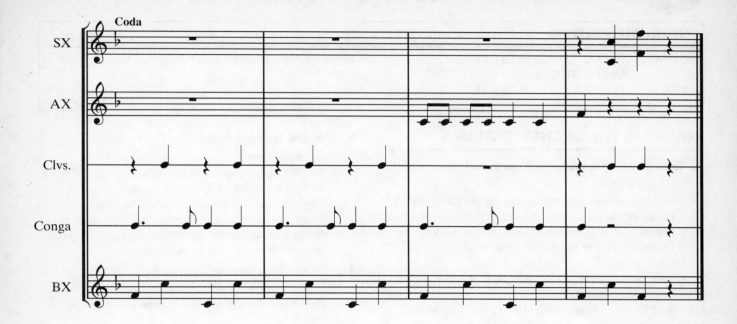

McGraw-Hill

0·15 The Ghost of John

INSTRUMENTATION

SG/SM	☐	☐	**E**	☐	☐	☐	☐	☐	☐	**E**	☐	☐	☐
AG/AX	☐	☐	**E**	**F♯**	**G**	**A**	**B**	☐	☐	☐	☐	☐	☐
BX/BM	☐	☐	**E**	☐	☐	☐	**B**	☐	☐	**E**	☐	☐	☐

finger cymbals, triangle, bass bars (opt.), various small percussion

TEACHING THE ORCHESTRATION

1. Teach the bass xylophone/bass metallophone part.

Have the students:
- Sing the song as you model playing the BX/BM part.
- Pat the rhythm of the BX/BM part as they sing the song.
- Mirror you, playing the BX/BM part in the air.
- Pat the rhythm of the BX/BM part as they sing the pitch names.
- Take turns playing the BX/BM part on any available barred instruments.
- Sing the song as one student plays the BX/BM part.

2. Teach the soprano glockenspiel/soprano metallophone, alto glockenspiel/alto xylophone, and finger cymbals parts.

Have the students:
- Perform the following body percussion, reading from the board or another visual:

- Transfer the claps to the AG/AX and the snaps to the finger cymbals and the SG/SM part playing E octaves.
- Take turns playing each part. Switch roles and repeat.
- Sing the song as some students play all the parts learned thus far.

3. Add the triangle part.

Have the students:
- Sing the song, clapping with the words *no skin on*.
- Write the rhythm on the board or other visual.
- Play this part on various unpitched percussion instruments (for example: cymbal, triangle, shaker, drum) with the words *no skin on*. Use a different instrument for each part of the canon.

4. Add the bass bar part (optional).

Have the students:
- Clap the rhythm of the bass bar part as they sing the song.
- Sing the song as one student plays the bass bar part.
- Combine all the parts to play the entire orchestration.

5. Add the introduction and the coda.

Have the students:
- Play all the instrumental parts for four measures for the introduction.
- Continue to play the accompaniment parts after the last voice of the canon finishes, gradually diminishing to *ppp* for the coda.

FORM

Introduction:	*tutti* instruments
Canon:	Voice, *tutti* instruments
Coda:	*tutti* instruments decrescendo to *ppp*

NOTEWORTHY

Rhythm:	half note, quarter note, eighth note
Melody:	E minor
Harmony:	bordun

0·15 The Ghost of John

Words and Music by Martha Grubb
Arranged by Carol King

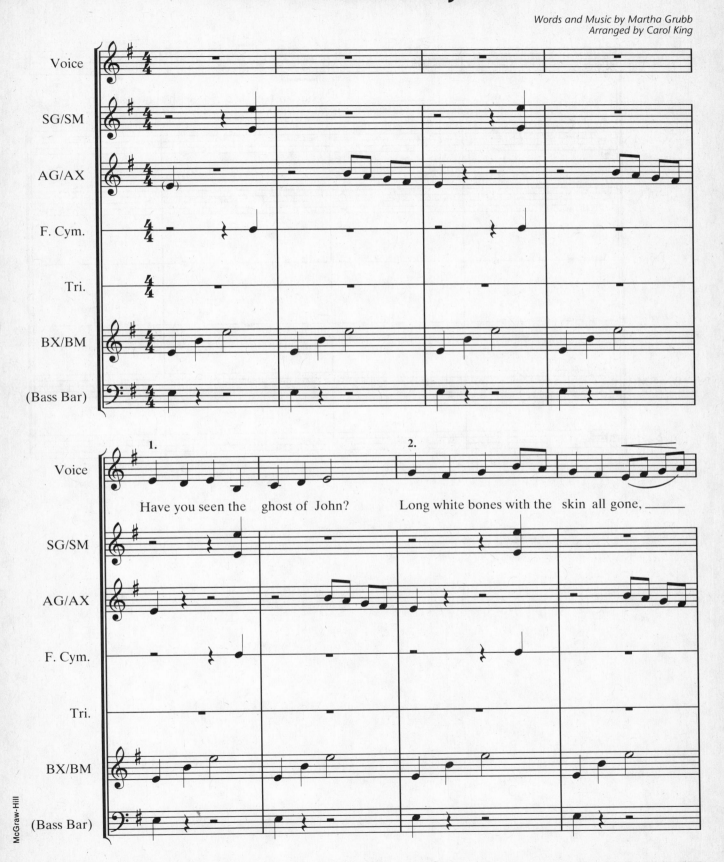

Have you seen the ghost of John? Long white bones with the skin all gone, _____

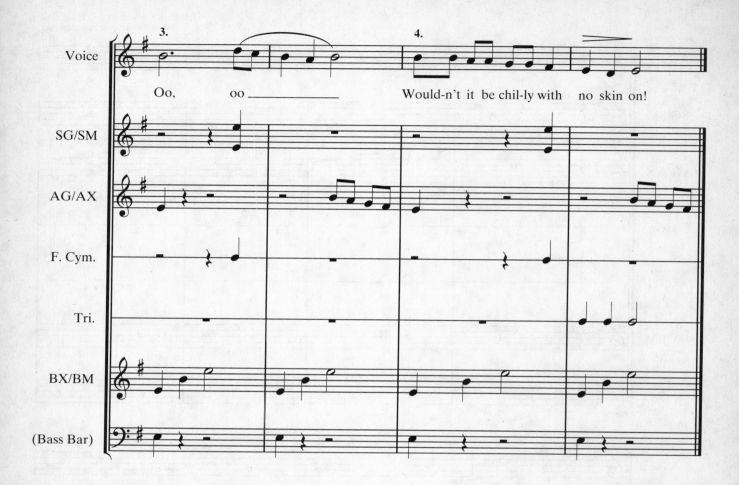

Oo, oo _____ Would-n't it be chil-ly with no skin on!

0·16 For Health and Strength

INSTRUMENTATION

SX/AG	**C** ☐	☐	☐	☐	☐	☐	**C**	☐	☐	☐	☐	☐
AX/AM (opt.)	**C** ☐	**E**	**F**	**G**	**A**	**B**♭	**C**	☐	☐	☐	☐	☐
BX/BM	☐ ☐	☐	**F**	☐	☐	☐	**C**	☐	☐	**F**	☐	☐

TEACHING THE ORCHESTRATION

1. **Teach the bass xylophone/bass metallophone part.**

 Have the students:
 · Pat the rhythm of the BX/BM part as they sing the song, using alternating hands and using the following pattern: left-right-cross-right.
 · Mirror you, playing the BX/BM part in the air.
 · Pat the rhythm of the BX/BM part as they sing the pitch names.
 · Take turns playing the BX/BM part on any available barred instruments.
 · Sing the verse as one student plays the BX/BM part. Note that the BX/BM part starts as the voices sing *health*.

2. **Add the alto glockenspiel/soprano xylophone part.**

 Have the students:
 · Pat the rhythm of the AG/SX part, beginning with the left hand as shown below:

 · Take turns playing the AG/SX part, using any available barred instruments.

· Sing the verse as some students play the AG/SX part with the BX/BM part. Have the SX players begin with Voice 1 and the AG players begin with Voice 2 of the canon.

3. **Add the alto xylophone/alto metallophone part (optional).**

 Have the students:
 · Clap the rhythm of the melody as they sing the song.
 · Sing the pitches from a visual.
 · Take turns playing the melody on any barred instruments.
 · Have some students play the melody in canon as others sing the song in canon—the AX part playing with the first voice, and the AM part playing with the second voice.

FORM

Canon
Voice 1: Voice, SX, AX, BX
Voice 2: Voice, AG, AM, BM

NOTEWORTHY

Rhythm: quarter note, eighth note
Melody: F major
Harmony: bordun

0·16 For Health and Strength

Old English Round
Arranged by Carol King

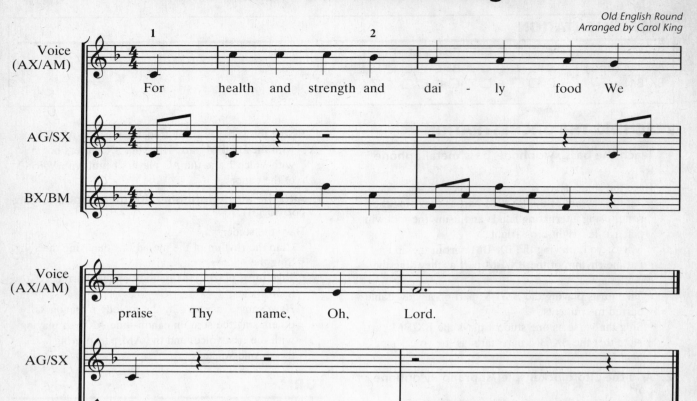

Voice (AX/AM): For health and strength and dai - ly food We

praise Thy name, Oh, Lord.

0·17 Entren santos peregrinos
(Enter, Holy Pilgrims)

INSTRUMENTATION

AG/SM	☐	☐	☐	☐	☐	**A**	☐	☐	☐	☐	☐	☐	**A**		
SX	☐	**D**	☐	☐	☐	☐	☐	☐	**D**	☐	☐	☐	☐		
AX	☐	**D**	**E**	**F♯**	**G**	**A**	**B**	☐	☐	☐	☐	☐	☐		
BX	☐	☐	☐	☐	☐	**A**	☐	☐	**D**	☐	☐	☐	☐		

maracas, guitar, timpani—tuned to A and D

TEACHING THE ORCHESTRATION

1. Teach the bass xylophone and timpani parts.

Have the students:

- Sing the song as you model the BX part.
- Pat the rhythm of the BX part as they sing the song.
- Mirror you, playing the BX part in the air.
- Pat the rhythm of the BX part as they sing the pitch names.
- Take turns playing the BX part on any available barred instruments.
- Sing the song as one student plays the BX part and you model the timpani part.
- Divide the class into two groups. Have Group 1 pat the rhythm of the BX part as Group 2 pats the same pattern on measures 4–5 and 9–10 only. Switch roles and repeat.
- Transfer the Group 2 part to the timpani. Have one student play the timpani part with the BX part, as the students sing the song.

2. Teach the alto glockenspiel/soprano metallophone, soprano xylophone, and alto xylophone parts.

Have the students:

- Divide the class into three groups. Assign each group to the following body percussion, reading from the board or another visual:

R L R

- Transfer the snaps to the AG/SM part, the claps to the AX part, and the pats to the SX part. Take turns playing each part. Switch roles and repeat. **Note:** You may have one student play both notes of the AX part or divide the part between two players.
- Sing the song as some students play all the parts learned thus far.

3. Add the maracas and guitar parts.

Have the students:

- Clap the beat as they sing the song.
- Transfer the beat to the maracas and the guitar, using a downstroke strumming motion.

FORM

Introduction:	First four measures, Mar., BX
Verse:	Voice, *tutti* instruments

NOTEWORTHY

Rhythm:	$\frac{4}{4}$, dotted quarter note, eighth note
Melody:	D major
Harmony:	I-IV-V

McGraw-Hill

0·17 Entren santos peregrinos
(Enter, Holy Pilgrims)

Mexican Folk Song
Arranged by Carol King

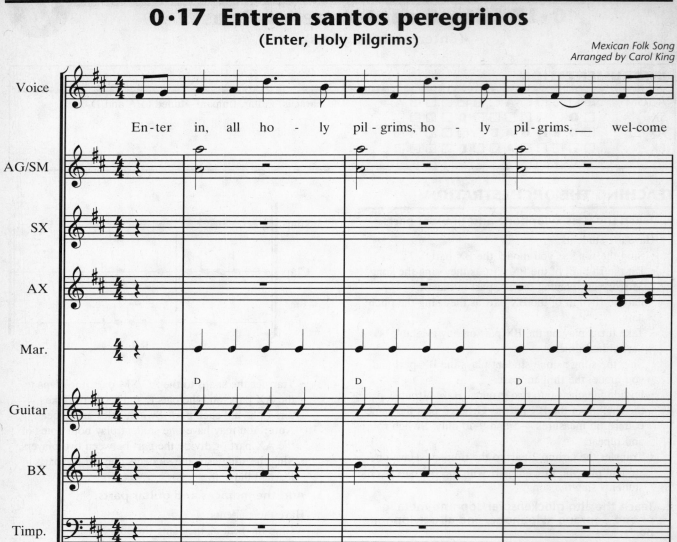

En-ter in, all ho-ly pil-grims, ho-ly pil-grims. ___ wel-come

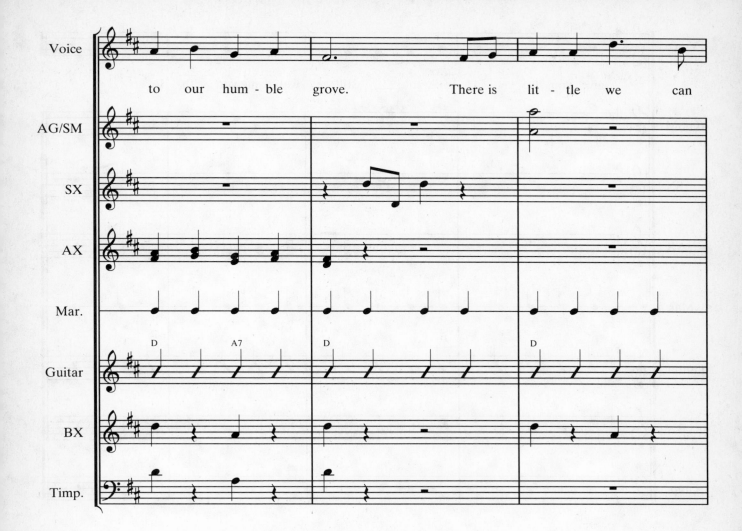

to our hum - ble grove. There is lit - tle we can

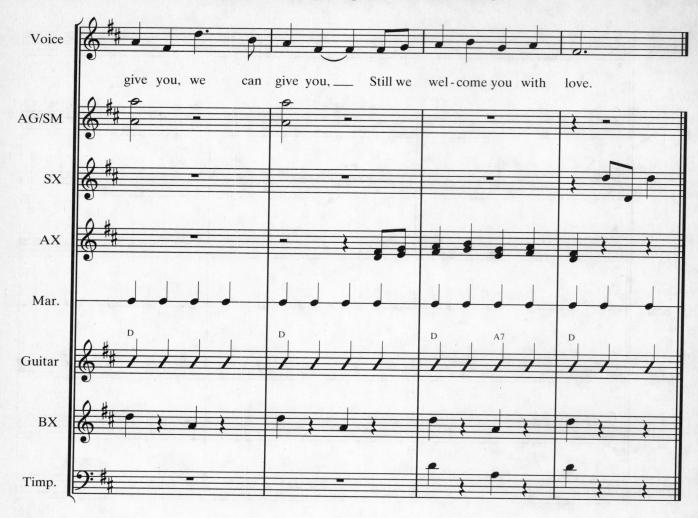

give you, we can give you, ___ Still we wel-come you with love.

MORE SONGS TO READ

The orchestrations in this section are specially arranged to reinforce the musical concepts in the lessons accompanying "More Songs to Read."

Most orchestrations will require part of several class periods to teach. In some cases, you may wish to just teach some just basic parts of the accompaniment (for example, the bass part and one "featured" instrument). In these cases, you could return to them later and complete them. In any case, it is unlikely that you will have time to teach all the accompaniments in this section. In fact, it is probably better to select just a few that seem best suited to your taste and needs than to try to do too many and overwhelm the students, or to teach them too fast and cause the students to be unsuccessful in learning them.

A posted chart for each orchestration that shows the instruments needed and the bars needed on each pitched instrument is helpful. The chart could include final instrument assignments when these are determined.

GENERAL SUGGESTIONS

1. **Teach one pattern at a time.** Have students:
 - Take their time in learning each part.
 - Feel comfortable with singing the song while playing a pattern before adding the next pattern.

2. **Teach each pattern through movement, with the song.** Have students:
 - Mirror you in doing each new rhythm pattern with body movement—preferably large locomotor movements (walking, jumping)—especially for parts that occur on the beat and/or the strong beat. Others can be done with body percussion patterns you create (snapping, clapping, patting and/or stamping) or mirroring you in doing the movements required to play the part on the assigned instrument.
 - Sing the song, doing the pattern in movement.
 - Remove any unused bars on pitched instruments to make understanding and playing the patterns easier.
 - Form groups of three or four students around any available instruments and take turns playing the pattern. (Later, the pattern can be assigned to the instrument indicated in the score. At this time, you only want to give all the students an opportunity to learn the pattern and to help others in their groups to learn it.)

3. **After teaching the most basic part, add other parts one at a time.** Have students:
 - Sing the song, watching and listening as you play each new pattern.
 - Figure out how the pattern relates to the song (On rhyming words? On a rest after a phrase?) and how it relates to previously learned pattern(s).

- Form two groups and sing the pitches or say the rhythm of the pattern while doing the pattern in body percussion (or by mirroring you) as the other group sings the song and plays any previously learned patterns. Switch roles for the groups and repeat. (Use speech patterns given, or create your own. Patterns occurring only on the beat and strong beat, or on a single note—such as at the ends of phrases—can usually be taught without spoken patterns.)
- All together, sing the song while doing the pattern in body percussion (or mirroring you).
- Clarify pitches played or learn about instrument technique as needed. Take turns playing the pattern while singing the song.

4. **Relate the accompaniment to the lesson focus.** Have students:
- Recognize and describe ways that the accompaniment connects with and relates to the musical focus of the lesson. (It is important for students to realize what they are learning musically and how playing the accompaniments contributes to this.)
- Review this connection each time you work on the orchestration.

5. **Perform the accompaniment as indicated in the score, or as adapted by you and the students.** Have students:
- Form groups at each instrument needed and take turns playing each part with the song. (Encourage the students to be aware of the quality of their singing. Practice without the accompaniment as needed for this to happen.)

Some Final Words: In some cases, you may wish to assign groups more or less permanently to each part. Through the year, try to give all students turns in playing each pitched instrument.

Try to take the time to provide a "complete" experience with the orchestrations you teach. To do this, once the accompaniment is learned, use it with the game or dance, find ways to provide opportunities for students to improvise, and introductions, interludes and codas of your own or devised by the students and, whenever appropriate, add dramatization related to the song. In other words, give the students time to enjoy their accompaniments and to make it "theirs." Above all, strive to make the experience joyful and memorable for both you and the students.

0·18 Night Song

German Folk Song
Arranged by Marilyn Copeland Davidson

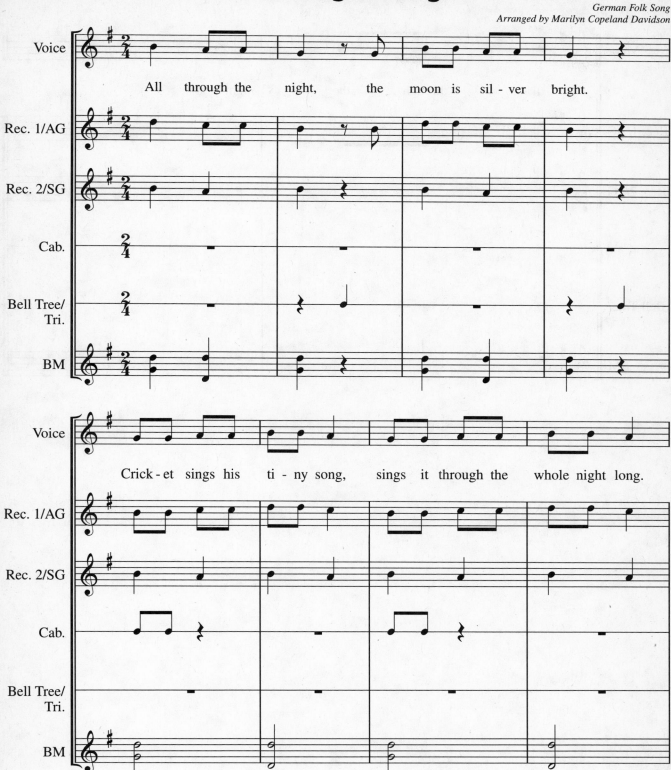

All through the night, the moon is sil - ver bright.

Crick - et sings his ti - ny song, sings it through the whole night long.

Night Song (continued)

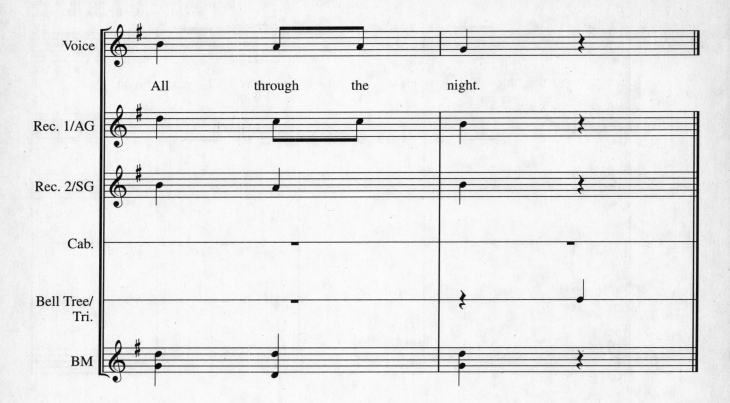

All through the night.

0·19 Babylon's Falling

Virginia Folk Song,
Arranged by Marilyn Copeland Davidson

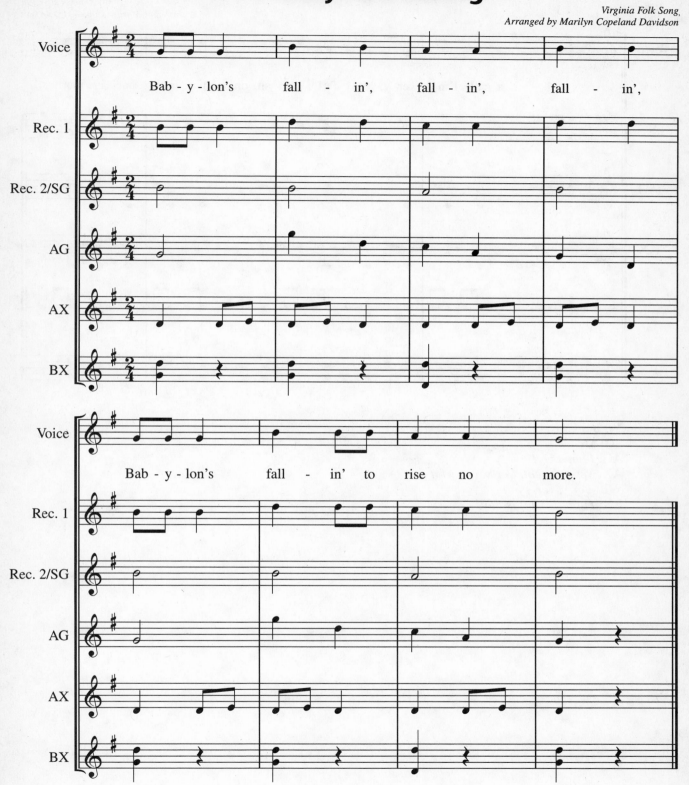

Bab - y - lon's fall - in', fall - in', fall - in',

Bab - y - lon's fall - in' to rise no more.

0·20 I Am a Cat

Anonymous Poem
Arranged by Marilyn Copeland Davidson

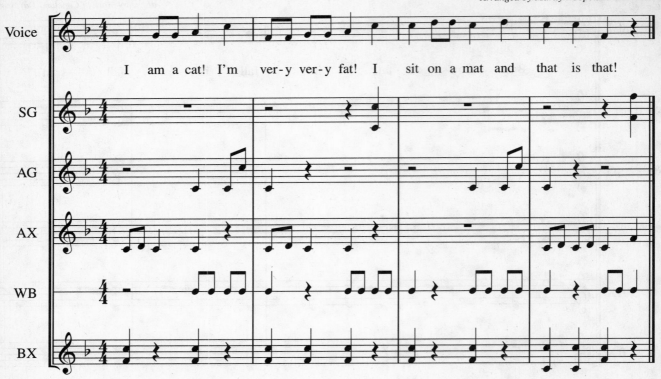

I am a cat! I'm ver-y ver-y fat! I sit on a mat and that is that!

Verbal Cues
SG: *Meow!*
AG: *I am a cat!*
AX: *Ver-y fat cat! Ver-y, ver-y fat cat!*
WB: *Ver-y, ver-y fat!*
BX: *Fat cat! That is that!*

American Minstrel Song
Arranged by Marilyn Copeland Davidson

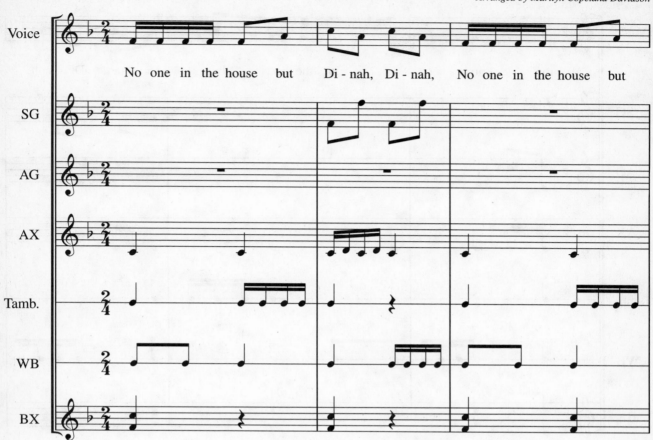

Verbal Cues

Tamb.: *House! No one's in the ...*

WB: *No one's home! No! Absolutely...*

AX: *House, house, no one in the house.*

BX: *House, house, house, house, no one home.*

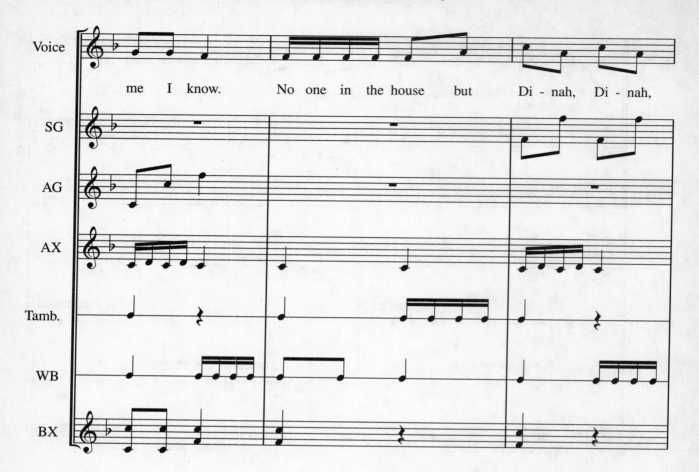

Play - ing on the old ban - jo.

0·22 The Old Chisholm Trail

Cowboy Song
Arranged by Marilyn Copeland Davidson

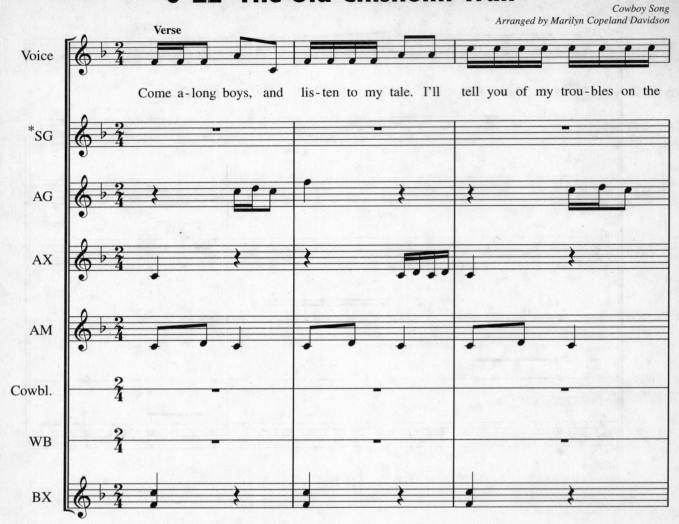

Come a-long boys, and lis-ten to my tale. I'll tell you of my trou-bles on the

*Have soprano glockenspiel, soprano recorders, and other available pitched instruments take turns improvising during the Verse in F pentatonic. Alternate sung verses and improvised verses.

Verbal Cues
AG: *Come a-long, boys.*
AX: *Yay! Yip-py, yip-py...*

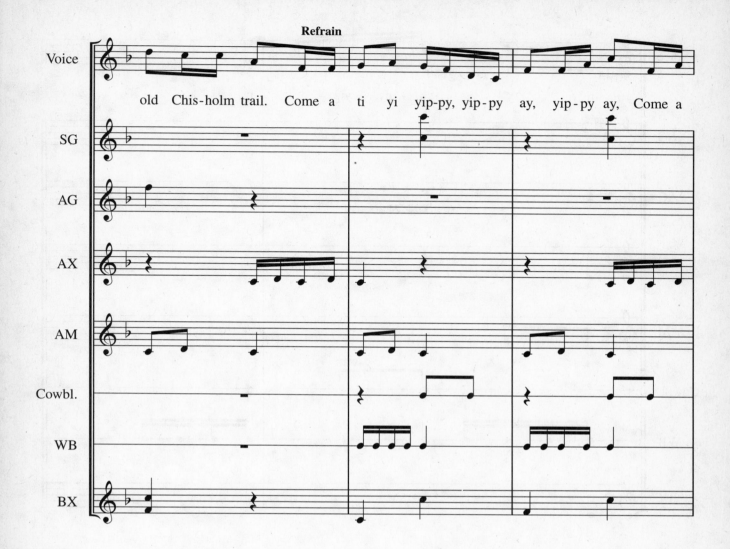

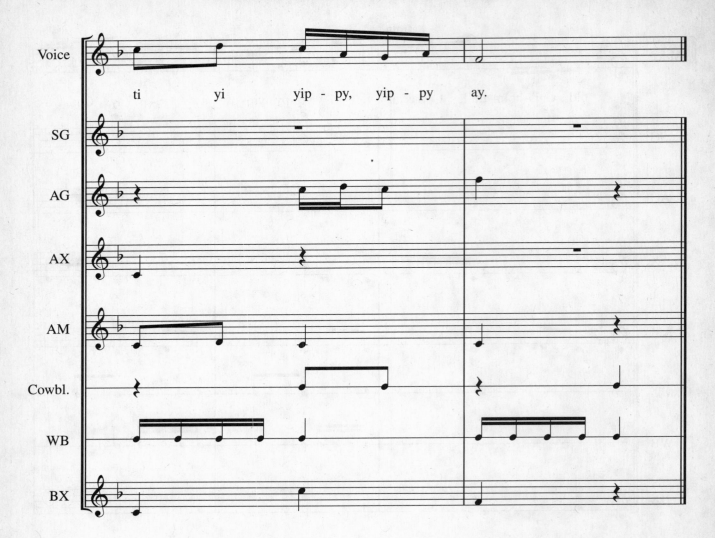

ti yi yip – py, yip – py ay.

0·23 Before Dinner

Zairan Folk Song
Arranged by Carol King

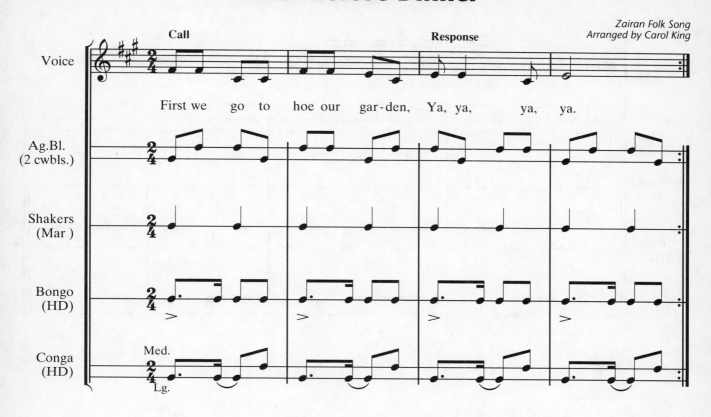

First we go to hoe our gar-den, Ya, ya, ya, ya.

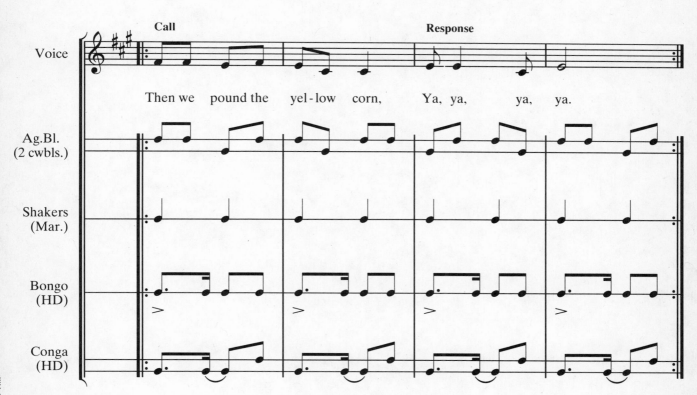

Then we pound the yel-low corn, Ya, ya, ya, ya.

Before Dinner (continued)

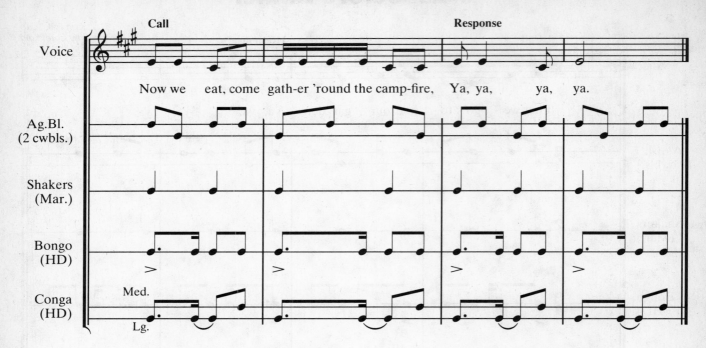

Now we eat, come gath-er 'round the camp-fire, Ya, ya, ya, ya.

0·24 Hop Up and Jump Up

Shaker Song
Arranged by Marilyn Copeland Davidson

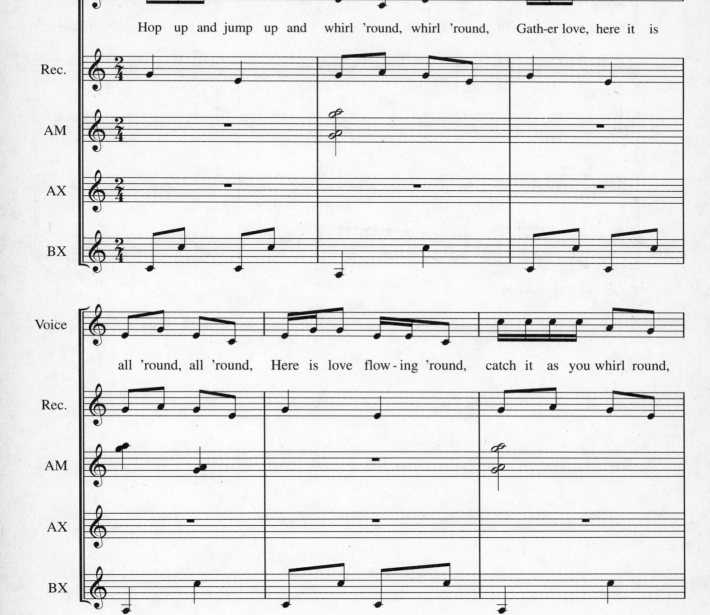

Hop up and jump up and whirl 'round, whirl 'round, Gath-er love, here it is

all 'round, all 'round, Here is love flow-ing 'round, catch it as you whirl round,

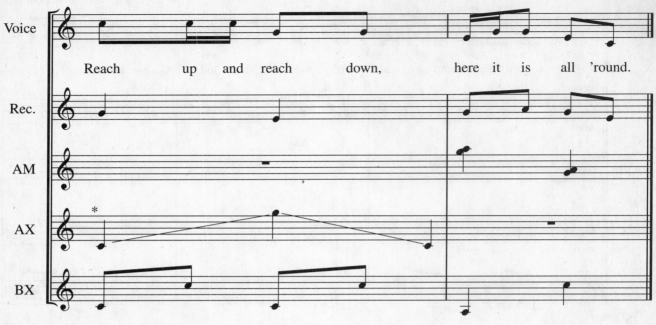

Reach up and reach down, here it is all 'round.

* Glissandi up and down

0·25 Oliver Cromwell

English Folk Song
Arranged by Marilyn Davidson

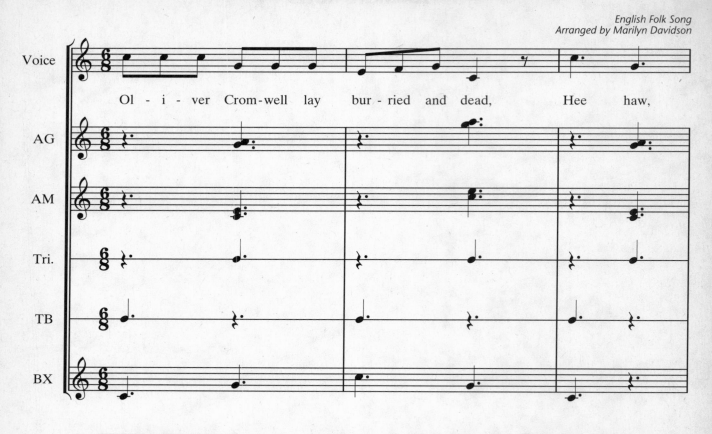

Ol – i – ver Crom-well lay bur – ried and dead, Hee haw,

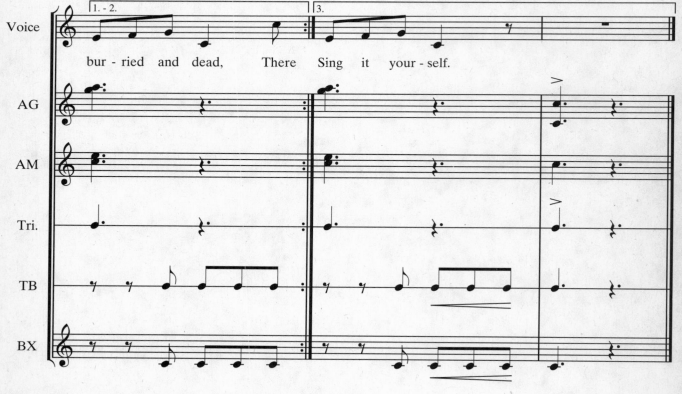

bur – ried and dead, There Sing it your - self.

0·26 John Kanaka

Sea Chantey
Arranged by Carol King

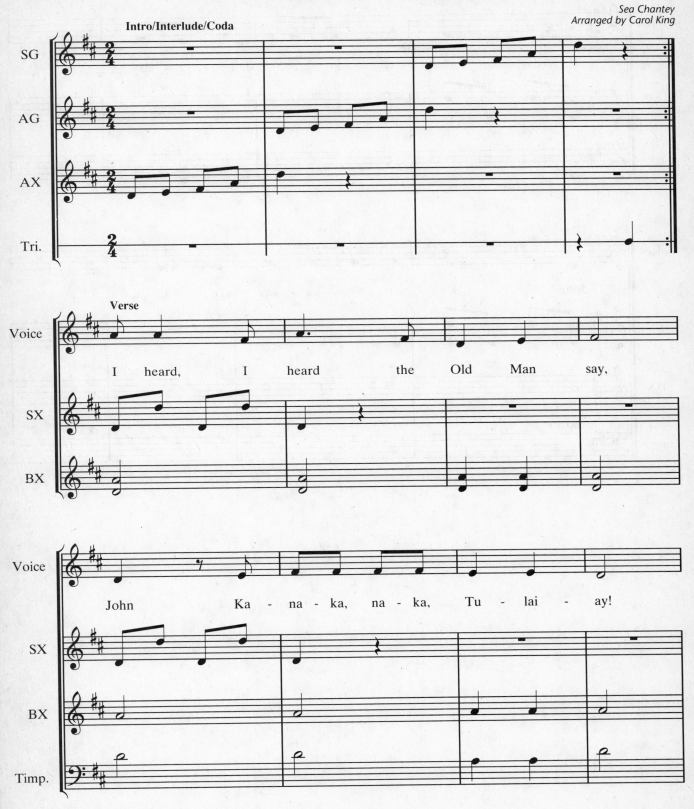

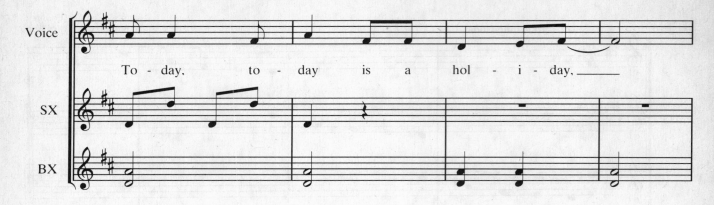

To - day, to - day is a hol - i - day, _____

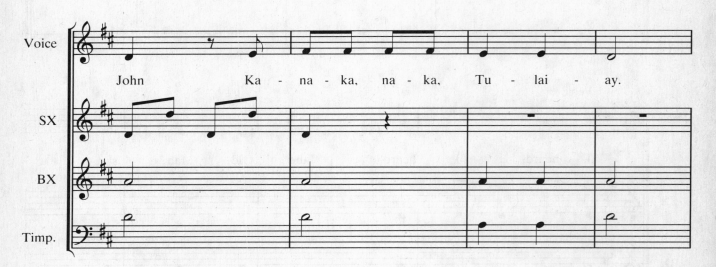

John Ka - na - ka, na - ka, Tu - lai - ay.

McGraw-Hill

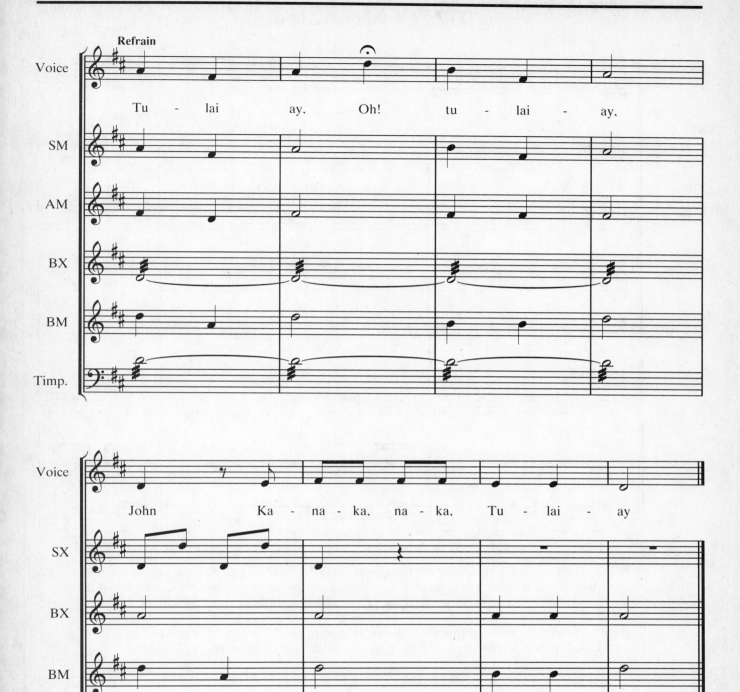

0·27 Chickalileeo

Southern Folk Song
Arranged by Marilyn Copeland Davidson

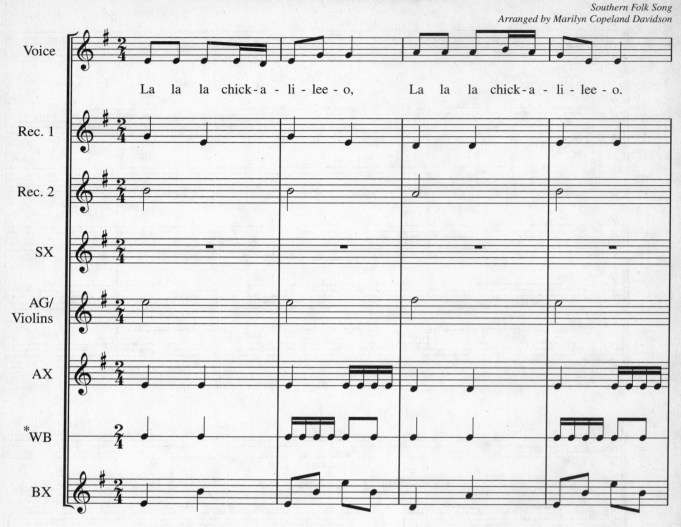

La la la chick-a-li-lee-o, La la la chick-a-li-lee-o.

* For variety, have different instruments tacet on some of the verses and play the woodblock part on different instruments. For example, have vibraslap play the quarter notes and washboard the sixteenth notes, or add cowbell on the quarter notes on one verse.

Have volunteers on other instruments take turns improvising 12-measure interludes beween verses on E G A B D. For an ending, repeat the first verse and have all improvisers play at once.

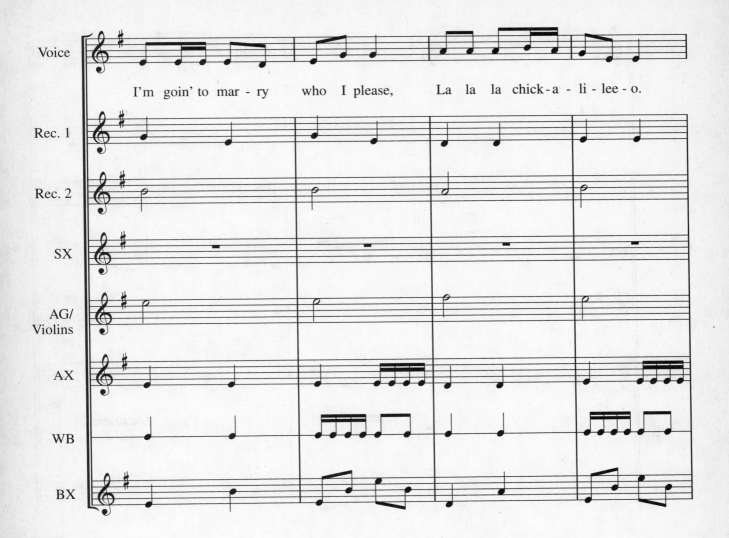

Voice: I'm goin' to mar - ry who I please, La la la chick-a - li - lee - o.

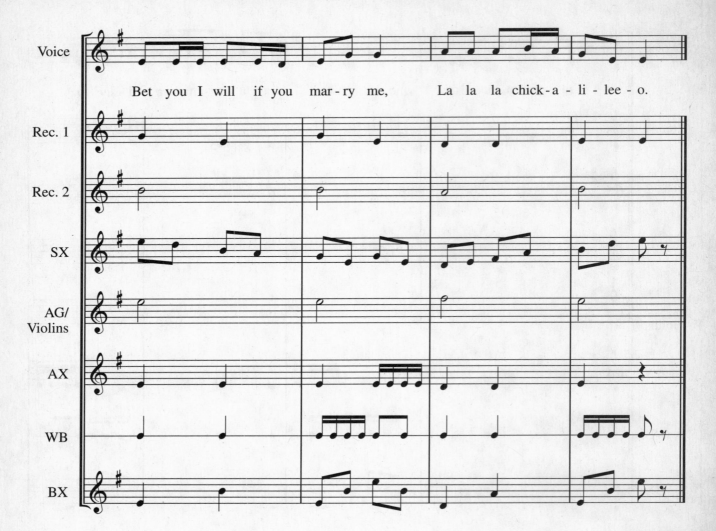

Bet you I will if you mar-ry me, La la la chick-a-li-lee-o.

0·28 Artsa Alinu

Israeli Dance Song
Arranged by Marilyn Copeland Davidson

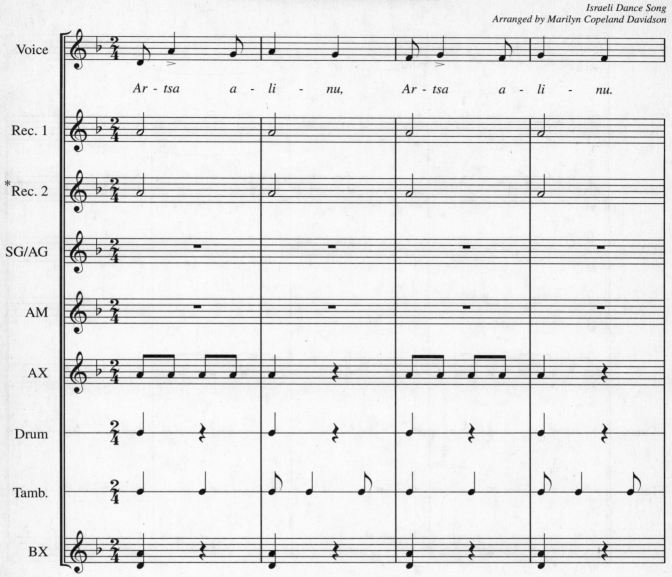

Ar - tsa a - li - nu, Ar - tsa a - li - nu.

* Recorder 2 does not include low D and E. Both recorder parts have the same rhythm throughout.

Fine

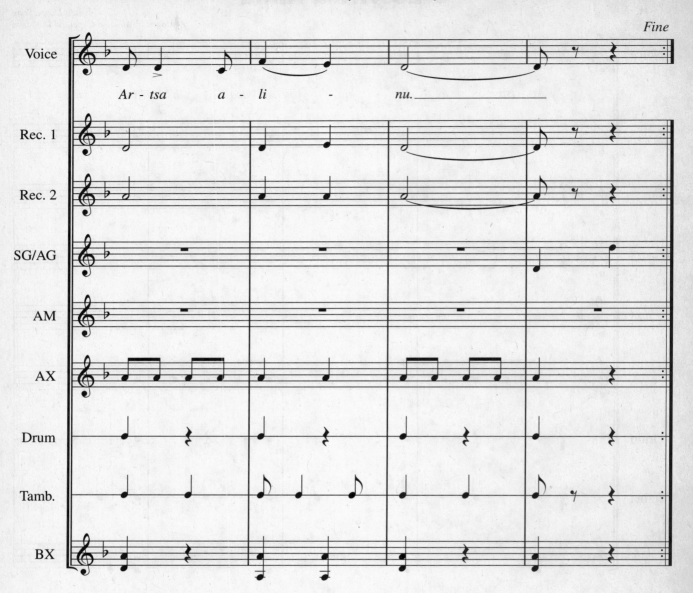

Ar - tsa a - li - nu._____

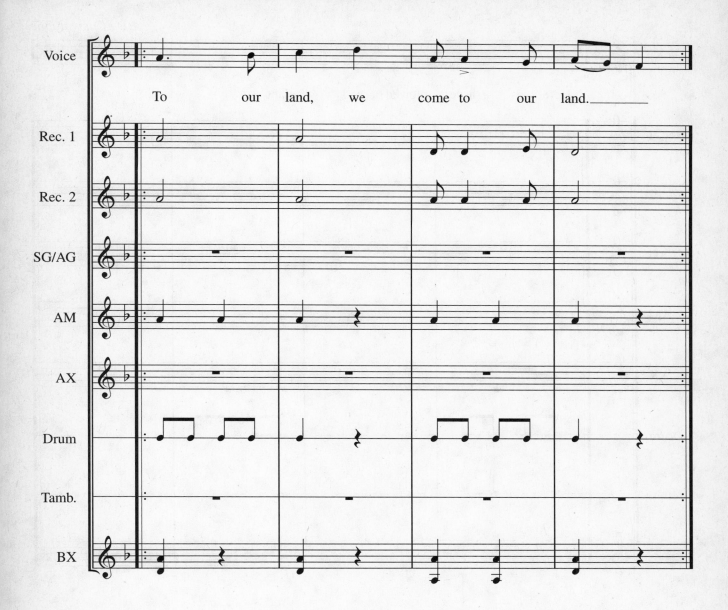

To our land, we come to our land._____

Artsa Alinu (continued)

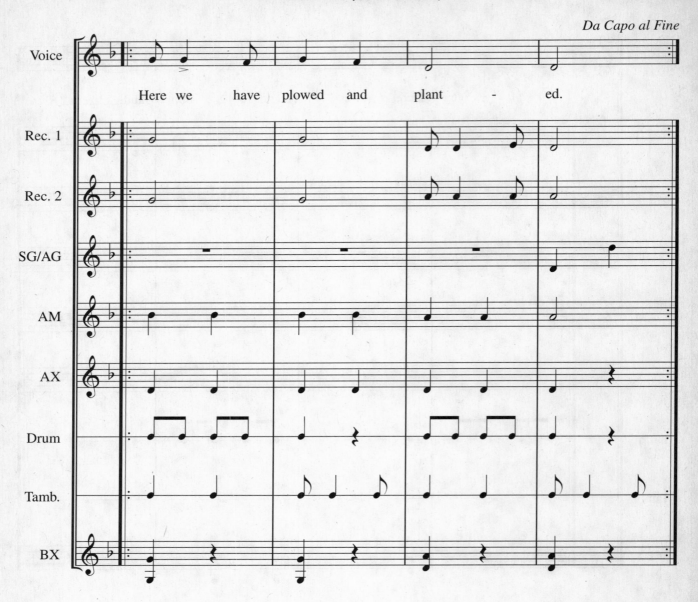

Here we have plowed and plant - ed.

0·29 Allundé, Alluia

- Use unpitched instruments on a two-measure ostinato to provide an introduction, accompaniment, and ending. Begin with maracas alone and add other unpitched instruments at two-measure intervals. Choral parts enter after the unpitched ostinato is completely established, on the third beat of the first ostinato measure. Continue the unpitched ostinato throughout the selection and the sung coda, ending quietly on the fermata.

- To use pitched instruments, have the Alto and Bass Xylophone ostinato begin after the unpitched ostinato is completely established and play for two measure before the voices enter. Play all pitched parts as written and continue through the refrain only. Pitched instruments are not used with the verse but may begin at the end of the verse to provide a two-measure interlude between the verse and refrain.

- Use the following entry sequence for the unpitched ostinato:

 1. Maracas—play seated and hold maracas upside down, with bulb in hands; hit legs with the bulb on down stem notes and shake maracas in the air on up stem notes.

 2. Large conga—strike center of head with fist on down stem half notes; strike edge of head with palm on up stem quarter notes.
 Begin at the end of the second measure.

 3. Medium conga—strike the side of the drum with a rhythm stick on quarter notes.
 Begin at the end of the second measure.

 4. Slit drum

 5. Bongos—play the lower pitch on down stem notes.
 Begin at the end of the second measure.

 6. Agogo bells—play the lower pitch on down stem notes.

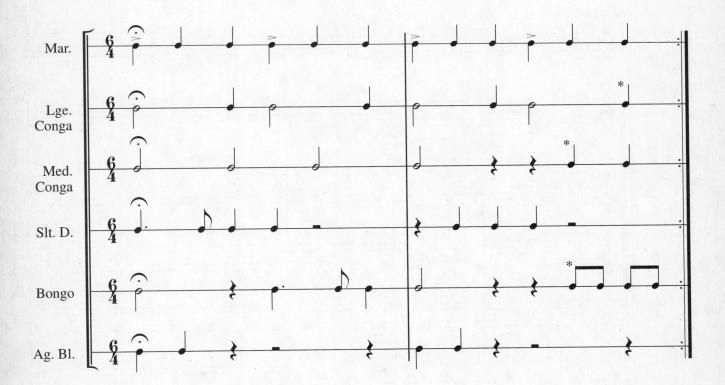

0·29 Allundé, Alluia

African Lullaby/Prayer
As sung and arranged by
Margaret Campbelle-Holman

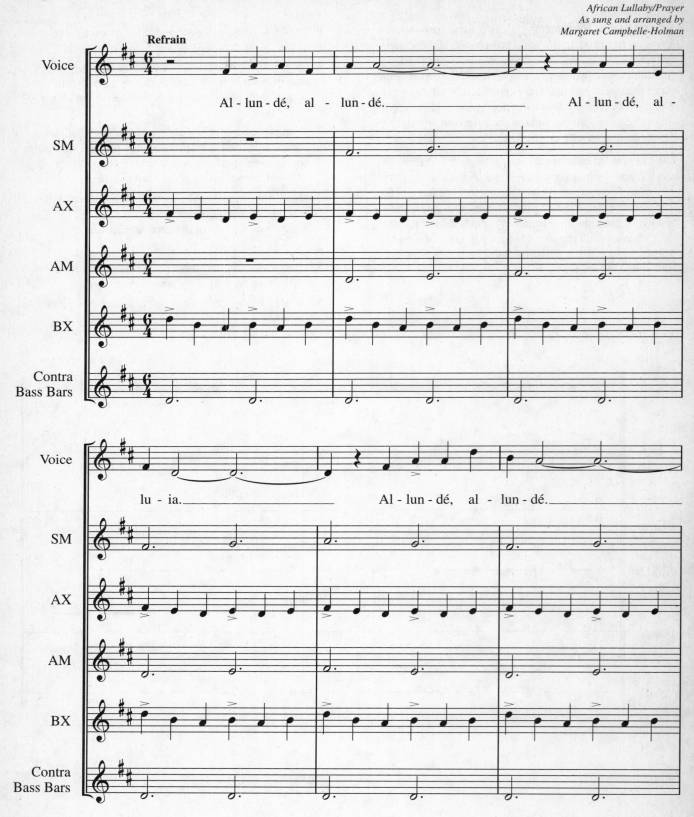

Grade 4

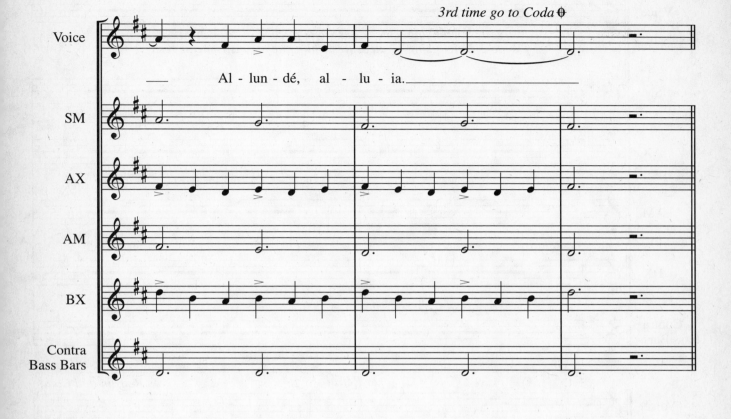

Al - lun - dé, al - lu - ia.

Allundé, Alluia (continued)

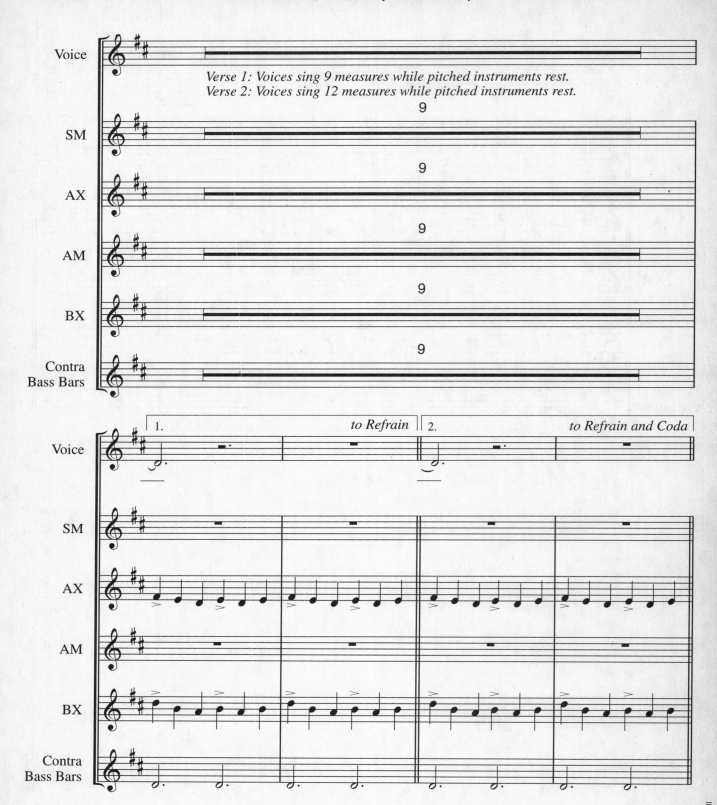

Verse 1: Voices sing 9 measures while pitched instruments rest.
Verse 2: Voices sing 12 measures while pitched instruments rest.

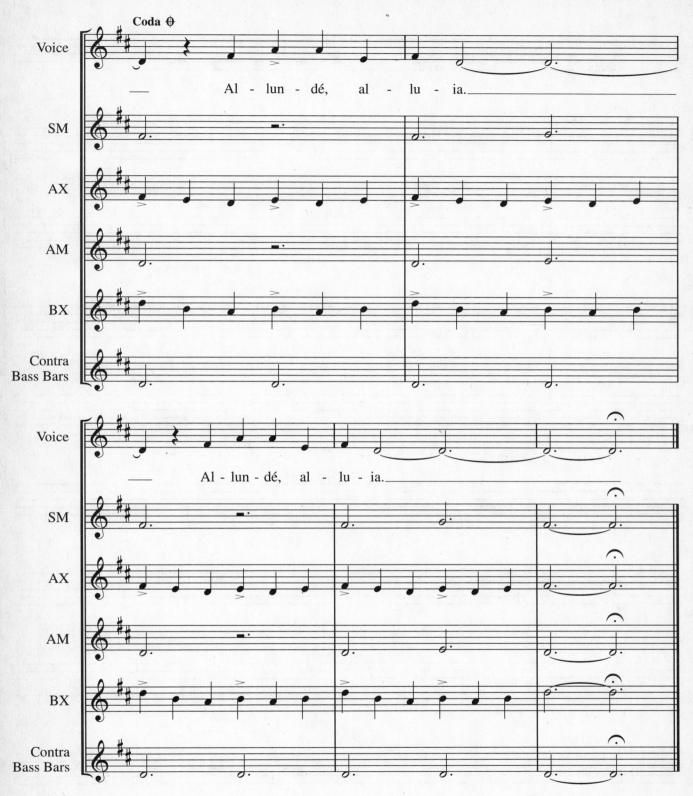

Al - lun - dé, al - lu - ia.

Al - lun - dé, al - lu - ia.